IMAGES
of America

SEA ISLE CITY
REVISITED

IMAGES
of America

SEA ISLE CITY
REVISITED

Donna Van Horn and Karen Jennings

ARCADIA
PUBLISHING

Published by Arcadia Publishing
Charleston, South Carolina

Printed in the United States of America

Library of Congress Control Number: 2013936610

For all general information, please contact Arcadia Publishing:
Telephone 843-853-2070
Fax 843-853-0044
E-mail sales@arcadiapublishing.com
For customer service and orders:
Toll-Free 1-888-313-2665

Visit us on the Internet at www.arcadiapublishing.com

*To the memory of Eleanor and John G. Pfeiffer, whose love of
Sea Isle was solidified by marriage and lasted a lifetime*

CONTENTS

ACKNOWLEDGMENTS

Karen and I come from a long line of pack rats. This tendency to never throw anything away can be attributed to the luxury of space to store the many boxes of photographs and aging newspapers that have filled dressers, closets, attics, and basements for well over 100 years. We sense a responsibility for preserving such historic material. How can one throw something out if someone treasured it enough to pack it away for safekeeping in the first place? The third floor of Pfeiffer's Department Store was a huge attic. As one generation passed on the business and attached living quarters to the next, the personal effects of the previous generation would be unceremoniously moved to the attic. Old clothes were packed into trunks for use as costumes, cherished toys were boxed away, and documents including marriage licenses, property deeds, and family Bibles were placed in attic storage. In 1964, when the family sold Cronecker's Hotel and Restaurant, the contents of that establishment were also moved to the attic above the store. Boxes of menus, napkins, and matchbooks joined crates of restaurant dishes and glassware. Cronecker family photographs finally joined those of the Pfeiffers and Sayreses in the attic, until the Pfeiffers retired and sold the store. Following John Pfeiffer's sudden death, and a debilitating stroke, Eleanor left Sea Isle to live with Karen in central New Jersey. In her last few years of life, Eleanor took great pleasure in revisiting her beloved Sea Isle City via the pictures and many mementos that she so cherished. Since Eleanor's passing in December 1999, Karen and I have continued to expand the collection. Except for a very few noted images, all of the postcards and photographs in this book are now in our personal possession. We wish to thank Barbara Colombo, owner of Coastal Postal in Ocean City, New Jersey, for her permission to reproduce some of her postcards to complete the collection. There is history worthy of saving in many an attic, and fortunately for those who love Sea Isle, this extensive collection can now at last be shared.

INTRODUCTION

According to an account documented in *A History of Cape May County, New Jersey*, written by Lewis Townsend Stevens in 1897, Joseph Ludlam "was here in 1692, and made purchases of land on the seaside, at Ludlam's Run, upon which he afterwards resided." At the time, Cape May County was completely isolated from the upper districts of the state by the extensive bed of cedar swamps and marshes that stretched for miles between the creeks traversing the area. No communication was available between residents of the county and those to the north or west except by the waters of the Delaware River or by horse paths through the swamps. Captain Kidd was reportedly "practicing his depredations" along the coast at this time and is said to have buried some of his booty in the sands along the barrier islands that hugged the coastline. In the early 1700s, the hardy residents of the mainland communities were predominantly whalers turned farmers, looking to make a living off the land and from the sea. Many early pioneers came from Long Island, New York, and New Haven, Connecticut, and found New Jersey's barrier islands perfect for pasturing cattle. They used brands known as earmarks, which were recorded at the county clerk's office to show ownership of the stock. Joseph Ludlam's earmark was an "L" placed under the left ear. Life on the mainland and Ludlam Island remained relatively unchanged until after the Civil War.

By the close of the Civil War, with the growth of nearby resorts including Atlantic City to the north, and Cape May to the south, Ludlams' Island presented a new and challenging opportunity for entrepreneur, Charles K. Landis. The son of Michael G. and Mary L. Landis, Charles was born in Philadelphia, Pennsylvania, in 1833 and was educated as a lawyer. He began his career as a real estate entrepreneur in 1857 with the development of Hammonton, New Jersey, in Atlantic County. Shortly thereafter in 1861, he purchased 20,000 acres of land near Millville, New Jersey, in Cumberland County, and built his first homes in 1862. He found this area especially desirable for development as it was along an existing railroad line with service to Philadelphia, with connections to New York City. Inspired by a visit to Venice Italy, in 1880 Charles Landis purchased Ludlam's Island in Cape May County with the intention of building a community that would include canals, fountains, and other works of public art. His Sea Isle City Improvement Company brought residents to the area, which eventually separated from Dennis Township and was incorporated as Sea Isle City, New Jersey, on May 22, 1882. The canals along the back bays of current Sea Isle are a direct result of Charles Landis' vision of a Venice on the Jersey coast.

Undoubtedly, it was the coming of the first railroad that played a critical part in the successful development of Sea Isle. Easy accessibility to the island from the mainland was crucial to the very survival of the community. The Ocean City Railroad Company (OCRR Co.) was formed in 1880 and track was completed into Sea Isle by 1882. Extension of this line north to Ocean City via Corson's Inlet and south to Townsends Inlet was completed by the close of 1884. The town grew quickly, and a post office was established with George Whitney as postmaster. The census of 1885 recorded 558 people as living in Sea Isle. During the same year, Ludlam's Beach

Lighthouse was built at Sea Isle, standing 36 feet above the mean high-water mark and visible at a distance of 11.25 miles. A countywide real estate assessment was conducted in 1887, with the total value of Sea Isle's property set at $237,365, followed by the first approval of a liquor license in 1888. A year later, Sea Isle City was described as "brilliantly illuminated at night with electric light, and the cottages and hotels are lighted by electricity."

By the summer of 1893, five trains arrived in Sea Isle and four departed daily during the week, and three arrivals and departures were scheduled on Sundays and holidays. By the close of the 19th century, with 30 hotels, an electric railroad, ice plant, schoolhouse, and two churches, Sea Isle was a well-established community, welcoming both year-round residents and seasonal tourists. Between the turn of the 20th century and the early 1920s, Sea Isle boasted two rail services, but the harsh saltwater environment created a constant battle to keep the rails passable across the meadows. The extensive maintenance required on the two drawbridges and several trestles caused the company to eventually abandon the tracks in 1925. By then, the automobile had become the travel method of choice for those visitors heading to Sea Isle. In the 1930s, auto travel continued to increase in spite of the Great Depression, and road improvements continued at a rapid pace as the government spent money on road construction, supposedly to provide jobs to the unemployed.

Charles Landis knew that, for a community to survive, the residents needed a place to worship. Whether you were a year-round resident, in Sea Isle for the summer season, or just "down for the day," the community needed churches. In 1881, Charles Landis donated a lot on the corner of Forty-fourth Street and Central Avenue to the Catholic church. Fr. Edward J. Egan became the first resident parish priest in 1889. The building has been enlarged twice and eventually relocated to Forty-fourth Street and Landis Avenue.

Landis also gave two lots to the Methodist church, which had been meeting since 1882 in the home of Mr. and Mrs. John Teleford. The cornerstone of the new church was laid in 1883, and the building was completed in 1884, with the Reverend Henry N. Chessman assigned as the first pastor. After the church was raised in 1897, a social hall was built underneath and heat was installed. To escape the noise of the trains, the building was moved in 1905. The congregation again built a new, larger church in 1958 on the corner of Park Road and Forty-first Street. In 1915, the first church services for Lutherans in the community were held at the Excursion House and the Moose Hall. In 1916, trustees John Gillision, Clarence Pfeiffer, C. George Cronecker, Herman Schnekel, and John M. Ross were charged with raising the funds necessary to purchase lots and build a new church. This first church was constructed in 1916, then rebuilt in 1936 directly next door to Pfeiffer's Department Store on Landis Avenue. In 1964, in celebration of the tercentenary of the State of New Jersey, a committee of Sea Isle City residents compiled a history of the resort community that acknowledged the "deep and abiding religious faith in the hearts and minds of the people of Sea Isle City."

Sea Isle is no different from many of the Jersey Shore communities in that it has seen prosperous times and lean times as well. Hurricanes and coastal storms have done significant damage over the years. Each time the community has rebuilt, changing its look ever so slightly yet not the feel of this small, close-knit town. As Sea Isle enters the 21st century, it continues to redefine itself, while building on its historical roots. While iconic community landmarks such as Cronecker's Hotel and Pfeiffer's Department Store have been lost to development, the town continues to treasure its past and take great pride in its future.

One

SOUVENIRS FROM
SEA ISLE CITY

Since its earliest days, Sea Isle City has always been a tourist resort. As the first hotel and the largest along the coast, the Continental began welcoming guests in 1889. Even a German newspaper was printed to accommodate the many guests of German decent who frequented the island. By 1890, there were as many as 30 hotels, 300 cottages, and a permanent population of 340 year-round residents. Joining the more modest fishing cottages were larger structures moved to Sea Isle from the Centennial Exposition in Philadelphia, Pennsylvania, where they were originally built for display as the latest in architectural design.

In 1930, in his book *An Historical Tour of Cape May County, New Jersey*, Julius Way described Sea Isle as the "Queen of Seashore Resorts." Situated on the Ocean Highway, 11 miles south of the larger community of Ocean City, Sea Isle possessed all the attractions of a modern oceanside resort. At the time, it made "an important link in the chain of cities by the sea" and was rapidly becoming a rival of them. Connected to the mainland by a turnpike across the meadows, the island was soon to be joined with the islands immediately to the south by means of new automobile bridges under construction over the intervening inlets. Possessing a remarkably broad, hard, gently sloping bathing beach, described by many as "the finest and safest beach on the Jersey coast," Sea Isle welcomed thousands of visitors each and every year.

Early visitors to Sea Isle, like most tourists coming to the Jersey Shore, spent at least a small portion of their leisure time writing postcards to the family and friends left behind. Since the idea for the postal card originated in Germany in 1865, it only made sense that the many German visitors to Sea Isle would carry on this old-world tradition. A message of "Welcome to Sea Isle" quickly became a coveted souvenir to send home while on vacation.

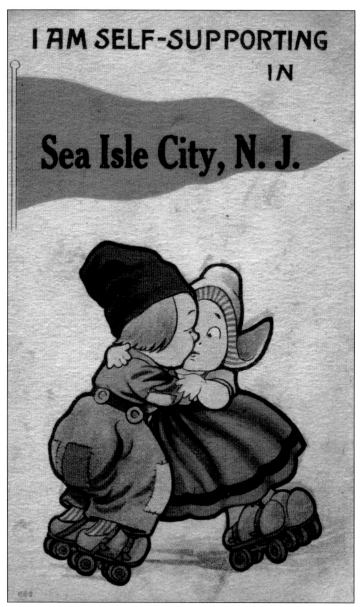

I AM SELF-SUPPORTING IN

Sea Isle City, N. J.

Sent in 1916, this postcard speaks to the German influence on the tourist market in early Sea Isle. Whether in Philadelphia, to where this card was addressed, or back in Germany, family at home could relate to the traditional costumes. Until the middle of the 19th century, people mailed messages to each other via the privacy of sealed letters. The idea for the postal card originated in Germany in 1865. It was the Austrian government, however, that issued the first postcard on October 1, 1869. Although many people thought it improper to mail messages on cards that anyone, especially the servants, could read, they soon became a hit with the general public. The first popular picture postcards in America were released in 1893 to commemorate the World's Columbian Exposition in Chicago. These were made from uncut sheets of the government penny postal cards, with images of the exposition buildings printed on the blank sides. Postcards quickly became an inexpensive way to send friends and family a snapshot of one's travels and surroundings, even photographs of one's home.

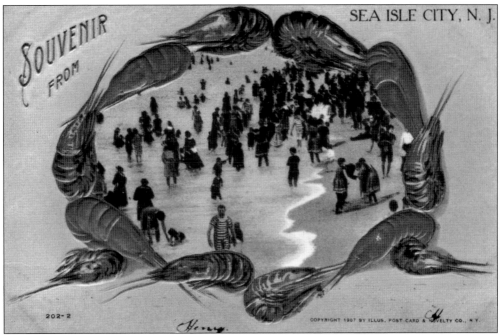

This welcoming beach scene from the early 1900s shows visitors wearing the typical swimming attire of the day. More formfitting suits would soon replace the "bathing dresses." In 1907, Australian swimmer Annette Kellerman created a sensation while visiting the United States by wearing a swimsuit that showed her arms, legs, and neck. A close fit that revealed the bodily shape underneath was considered by many to be indecent exposure.

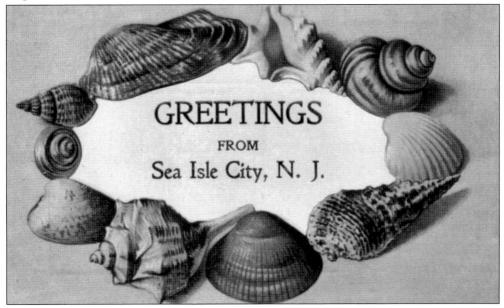

This simple shell design can be found on postcards from many of the Jersey Shore resorts. Originally printed in full color, the shells are all typical of those found on the beaches of Sea Isle. The Victorians enjoyed gathering seashells and proudly displayed them in their homes as souvenirs of their travels.

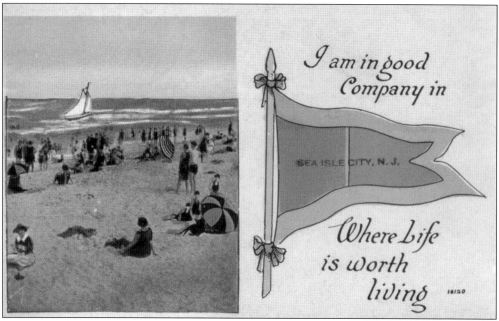

Resort travel in the early days of the 20th century was often an expensive undertaking. Only those families with substantial financial means could afford the $50 per week cost of a seaside vacation. This early postcard hints at the social status of those who vacationed in Sea Isle, indicating that this tourist was "in good company."

By 1942, bathing suits had changed and so had access to Sea Isle, now easier by both rail and automobile. Tourists continued to flock to the beach, especially day-trippers, often referred to as "shoobies," in reference to the days when a train ticket for a beach excursion included a boxed lunch. The writer of this postcard declares, "Down here for a few weeks and having a swell time. Swimming twice a day. Learning to swim and how! Girls! Girls! Girls! They're driving me nuts!"

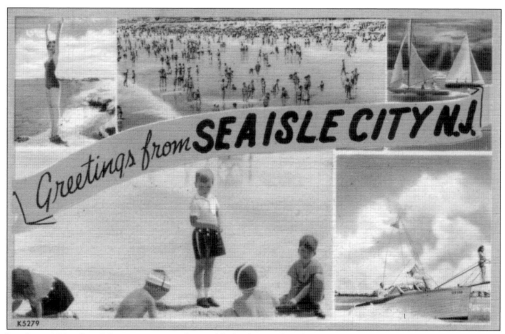

In the 1950s, Sea Isle was now well established as a family resort, with a variety of activities to entertain those of all ages. The ever-enticing beach combined with powerboating and sailing attracted more and more visitors each year. Many new homes were being built, and increasing numbers were making Sea Isle their year-round retirement home.

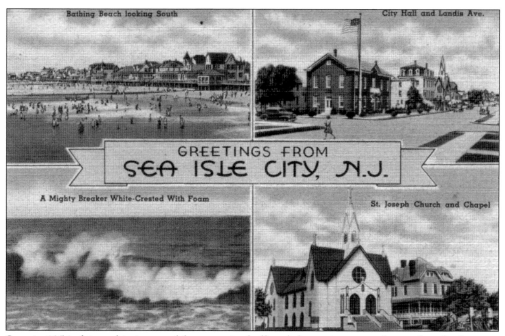

Sent in 1954, this multi-view card features city hall and the main street of town, Landis Avenue. St. Joseph's Church, built in 1888, was later moved from Forty-fourth Street and Central Avenue to Forty-fourth Street and Landis Avenue.

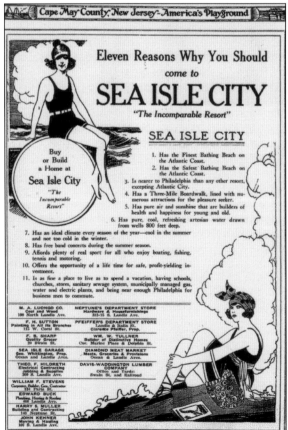

Spelled out in large letters for all to see, town- and state-name postcards were all the rage in the 1940s. In the same style as the now famous "Greetings from Asbury Park" postcard featured by rock legend and New Jersey native Bruce Springsteen on his album of the same name, this souvenir of a Sea Isle summer vacation is a cherished possession. Known as large-letter postcards, these popular vintage linen cards contain the name of a place shown as a series of very large letters, inside each of which is a picture of that locale. In this card, powerboats, sailing, and swimming are all featured. The boardwalk bandstand is visible in the letter "I" of "City."

This advertisement from the late 1920s entices potential visitors and investors alike to come to "The Incomparable Resort."

Two

LET'S GO FISHING

Can you really see whales off the shore of Sea Isle City? That question would have seemed absurd to early county settlers, many of whom made their living whaling in the Delaware Bay and Atlantic Ocean. Many whales could be seen swimming along the beaches of Sea Isle and occasionally would wash ashore. Sadly, too many were killed in too short a time, causing the destruction of the whaling industry. Yet Sea Isle continued to experience a strong fishing tradition, focusing on the more plentiful small fish of the back bays. An advertisement for the New Jersey Central Railroad touted Sea Isle City as a "favorite resort for fishing parties, for here are the famous Corson's Inlet sheepshead fishing grounds as well as a labyrinth of smaller waterways, teeming with shellfish of every description." Sea Isle has always experienced successful flounder fishing because the waters off the shore are constantly interacting with the Hudson River, the Delaware River, and the Gulf Stream, thus creating the ideal fishing conditions. The island is a well-known area where the popular and tasty flounder can be found.

Sea Isle is one of the five largest working fishing ports in New Jersey. In celebration of this rich fishing tradition, the city now holds an Annual Fish Alley Festival each June. Fish Alley has a storied tradition in Sea Isle City. Years ago, when asked where to buy fresh fish in Sea Isle, tourists were directed to Fish Alley. Settled by Italian immigrants in the early 1900s, the cottages on the back bays and marshes became the heart of this small fishing village that continues to thrive. Thanks to the efforts of Michael Monichette, owner of Mike's Seafood and grandson of Lodovico and Rosina Monichette, who arrived in Sea Isle via Ellis Island in 1911, the rich history of Fish Alley is being preserved. Four generations of the Conti family have also worked in the Sea Isle fishing business and now own a fleet of fishing boats, as well as Carmen's Seafood Restaurant, a bait and tackle shop, and a boat rental business.

Greetings from Sea Isle City, N. J.

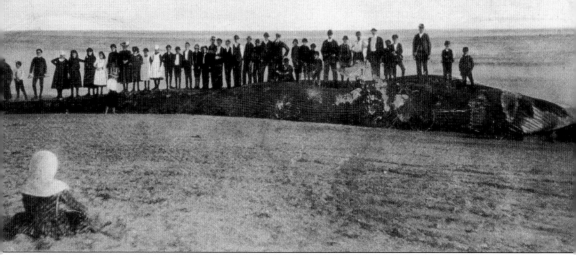

Just as the sighting of a whale today inspires awe and excitement in those lucky enough to catch a glimpse of one of these behemoths, a beached whale in the early 1900s always brought out the sightseers. In 1910, this large whale earned "famous" status when it sadly ended up on Sea Isle's beach. Offshore whaling was done from 20-foot whaleboats. When a whale was spotted, the boats were launched from the beach and the sails were raised. As the crew of eight neared the whale, they lowered the sail and rowed closer to it. Once the whale was harpooned, it would pull the boat until it tired, at which point the captain would drive a lance into the whale, trying to strike a vital organ. The angered whale would make another run until it finally tired and died. The whale was then towed back to the beach, where the blubber and baleen were processed.

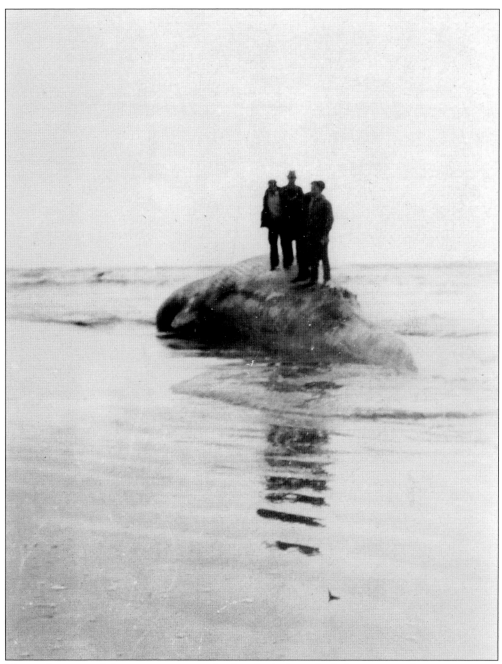

Notice the attire of the men examining this beached whale. Only hats, ties, and sport coats were suitable for such a notable event as a whale stranded on the beach. When a whale beached on the island, the locals documented the event with a photograph. Standing on the poor creature's back provided an excellent point of reference as to the size of the whale. Occasionally, whales still wash up on South Jersey beaches. While most are already dead, either from natural causes or from injury caused by a collision with a boat, some appear to have been purposefully killed by humans. Whales are among the species protected by the 1972 Marine Mammal Protection Act. Violators can be fined up to $100,000 and sent to prison for a year.

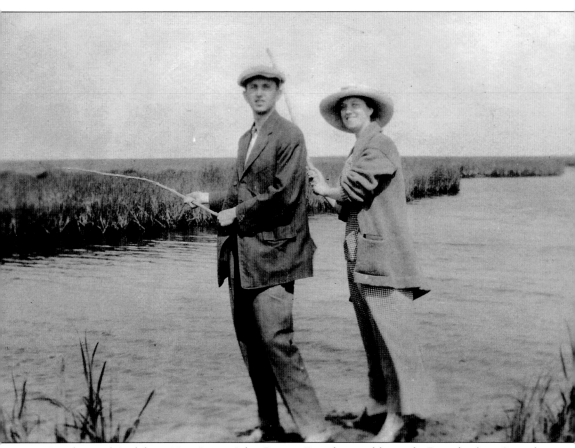

Residents of Audubon, New Jersey, John Branin Douglass and his wife, Dorothy (née Sayres), regularly visited family in Sea Isle City. Here, they enjoy a day of fishing in the back bays. Their homemade tree-twig fishing poles might have posed a challenge had they tried to fish in the ocean breakers. Dorothy's great-uncle George Sayres Sr. was an early officer of the Sea Isle Lifesaving Station.

In the picture at the right, Wheaton Douglass, wearing his 1912 Lehigh University letter sweater, shows off a very successful day's catch of weakfish. Recreational and commercial fisherman alike benefitted from Sea Isle's "bounty of the sea." Douglass was just one of the many visitors who returned to Sea Isle City each and every summer to fish in the back bays. The cool ocean breezes provided relief from the heat and humidity of Cape May Court House on the mainland, where his parents, Judge Harry S. and Marion (née Wheaton) Douglass, lived. In the bottom picture, Wheaton poses with a large blue fish, which was sure to be enjoyed at dinner that night.

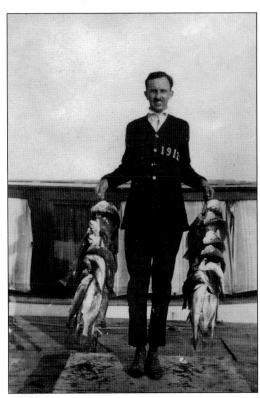

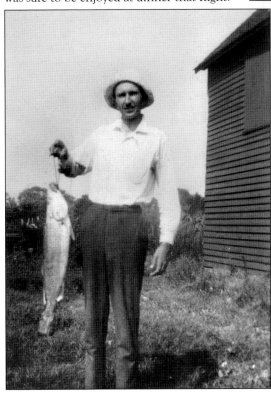

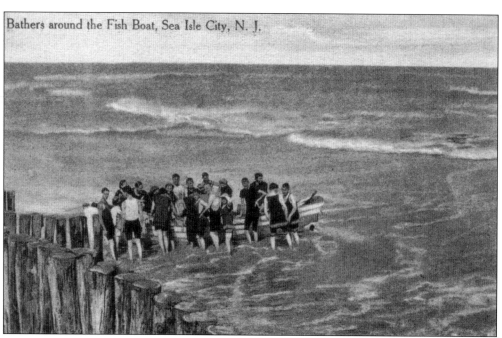

Bathers around the Fish Boat, Sea Isle City, N. J.

The visitor to Sea Isle who sent this postcard in 1913 noted, "Here's where they catch fish by the boat load and empty out with bushel baskets."

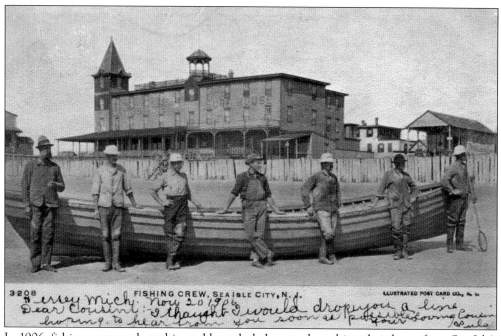

FISHING CREW, SEA ISLE CITY, N. J.

In 1906, fishing crews such as this could regularly be seen launching their boats from Sea Isle's beaches. Pound fishing was the first type of commercial fishing, eventually giving way to "dragging." The Sea Isle Fish Company, incorporated in 1913, was just one of numerous companies operating on the island.

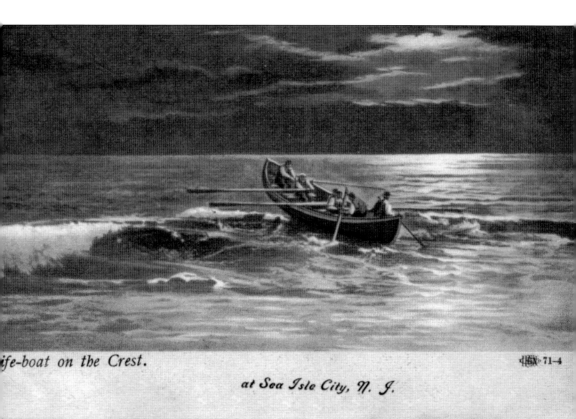

ife-boat on the Crest. 71-4

at Sea Isle City, N. J.

This postcard from 1908 depicts one of the lifesaving boats that was launched to assist when a whaling or cargo ship was in distress. Sailing along the coast was extremely hazardous in the days before lighthouses to warn of shoals and other dangers. So many ships wrecked that the government erected three lifesaving stations on the island: No. 32 in Corson's Inlet (eventually moved to Strathmere), No. 33 in Sea Isle, and No. 34 in Townsends Inlet. The Sea Isle City Coast Guard Station was authorized in 1849 but not built until around 1872.

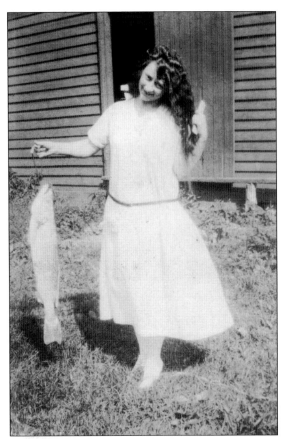

Recreational fishing was not just for the men. In this c. 1900 photograph, Ruth Yearik proudly shows off her rather impressive catch. Hopefully she was not wearing this pretty white dress when she caught her prize!

Clarence Pfeiffer recognized the potential of the commercial fishing industry in the area and purchased 25 shares in the Union Fishing, Freezing & Cold Storage Company in 1926. The note along the left side of this stock certificate indicates, "The common stock has been increased to 1000 shares." Business must have been good at the time.

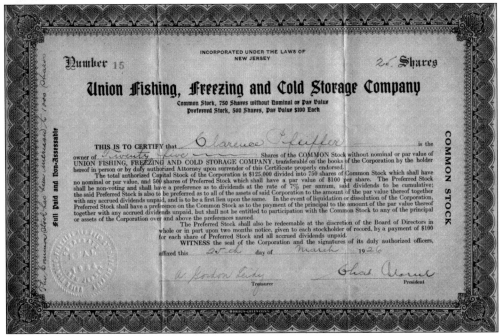

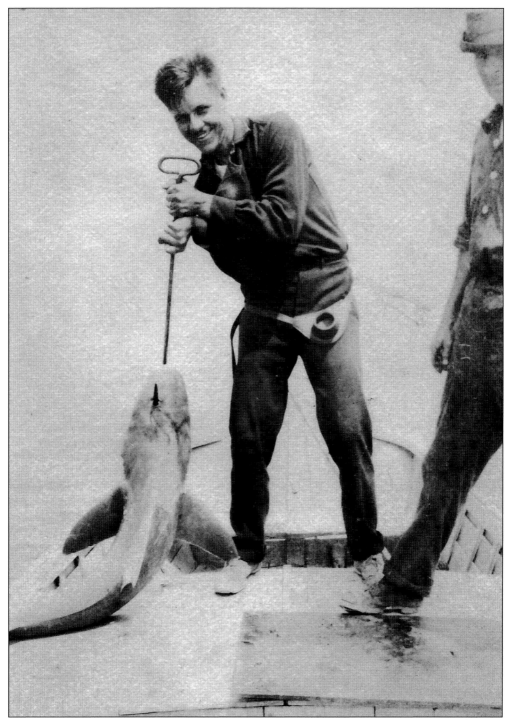

Whales and dolphins were not the only large catches sought by commercial fishermen. Sharks proved a challenge in not only hooking but also simply boating. Hard-hitting and fierce-fighting, sharks are a great fish to pursue. The nonstop action holds the interest of the youngest fishermen to even the most experienced anglers.

Many of the early structures built on the island were waterfront cottages, designed specifically to provide shelter during a day of fishing. These cottages were the scene of many summer gatherings and activities besides fishing. Beach parties, clambakes, and sack races were all part of regular family gatherings. This unidentified visitor seems quite content to just sit and relax.

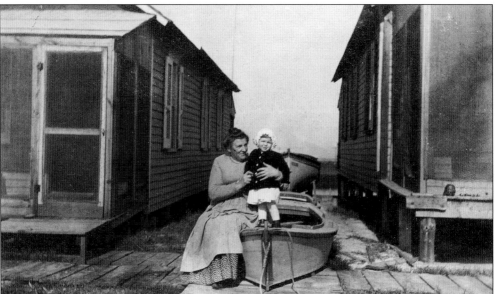

Posing on the bow of a fishing boat, Margaretta Pfeiffer is shown with Mrs. Peterson near one of the fishing cottages. The cabins were often built on short pilings, lifting them only slightly off the sandy beach surface. Small screened porches provided protection from the mosquitoes and "no-see-ums" that often plague the summer months.

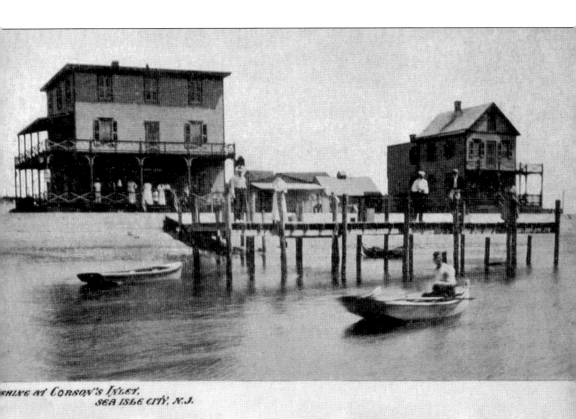

FHING at CORSON'S INLET,
SEA ISLE CITY, N.J.

This group of well-dressed anglers appears, by today's standards, far more ready for a formal wedding than a day of fishing. Note the ladies' hats and long dresses. Corson's Inlet is at the northernmost end of Ludlam Island, in what is now Strathmere. The inlet separates Sea Isle and Strathmere from neighboring Ocean City.

MISS TOWNSEND'S INLET II, SEA ISLE CITY, NJ

In the 1960s, this postcard called for the visitor to "enjoy 1/2 day fishing with Capt. Frank Marche aboard the biggest and fastest all aluminum double deck board in the area. Bring your family and join our courteous crew for a day of fine fishing and fun." Deep-sea, back-bay fishing and cruising are favorite vacation pastimes when visiting Sea Isle.

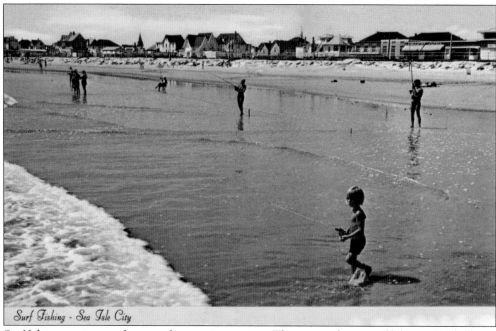

Surf Fishing - Sea Isle City

Surf fishing continues to be a popular vacation pastime. This postcard touts surf fishing as "a challenge to the young and old. Sea Isle City, like all the New Jersey shore line, has excellent surf fishing which produces great fun and relaxation." For many anglers, landing a fish after wading through pounding waves can be a greater thrill than reeling up a catch from the comfort of a boat.

Three

HOW ABOUT
A BOAT RIDE?

In the mid-1800s, many of the early residents of the nearby mainland communities were employed in the shipbuilding and shipping industry. Ships carried clams and cordwood to New York, bringing back manufactured goods not available on the cape. There were many shipwrecks off Ludlam Island, and according to local history, a pirate's pistol was reportedly found in the dunes. Men who spent their working hours on the water most certainly were drawn to boating as a leisure time activity as well. When Charles K. Landis purchased the island in 1880, he recognized the potential draw of the water and the popularity of boating, knowing that, when combined with the beautiful beaches, the canal-like waterways would appeal to fans of pleasure boating. The waters of the back bays provided the perfect place for simply cruising or the excitement of a challenging race.

For powerboaters, a small scow was designed especially for the New Jersey coast called the Jersey garvey, also known as the "baymen's boat." This flat-bottomed boat was long and narrow, with a shallow draft suitable for maneuvering in water often less than two feet deep. Made of native Atlantic white cedar, the original garveys were between 14 and 30 feet. The design allowed for little or no wake and only a small draft, which made it perfect for clamming in the shallow marshes, mudflats, and back bays.

Early sailors were partial to catboats, or cat-rigged sailboats, characterized by a single mast carried well forward. The traditional catboat had a wide beam approximately half the length of the boat, a centerboard, and a single gaff-rigged sail. Dinghies were used to transport passengers to and from the island when the only access was by water. Also known as a dink or tender, dinghies were sometimes equipped with a single mast and sail but were usually propelled simply by oars. Whether recreational sailing, yachting, or powerboating, the draw of the calm back bays and the challenge of the open offshore waters continue to appeal to residents and tourists alike.

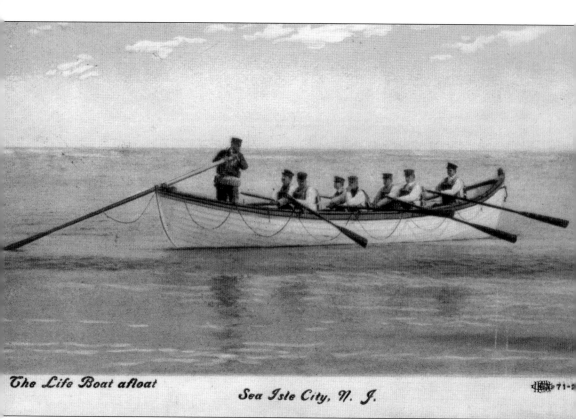

The Life Boat afloat

Sea Isle City, N. J.

This postcard, mailed in 1908, provides a great view of one of the lifesaving boats ready to come to the rescue. Prior to the establishment of the US Lifesaving Service (USLS) as a government agency in 1848, the lives of shipwrecked mariners and passengers were totally dependent upon local volunteers and private groups for rescue when in distress. In 1915, the USLS merged with the US Coast Guard, upon which millions of boaters now depend for rescue in a maritime emergency.

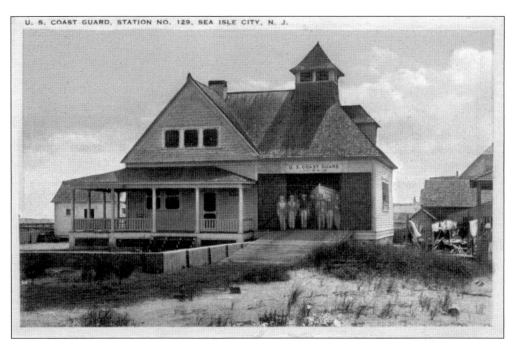

Lifesaving Station No. 33, also known as US Coast Guard Station No. 129, was authorized in 1849 but not built until around 1872, then abandoned in 1939. Keepers included David Townsend (1872), John M. Townsend (1875), George Sayres Sr. (1877–1893), John S. Cole (1893–1912), and Aaron Smith (1912–1915). George Sayres Sr. was the great-grandfather of Eleanor Pfeiffer, owner of Pfeiffer's Department Store.

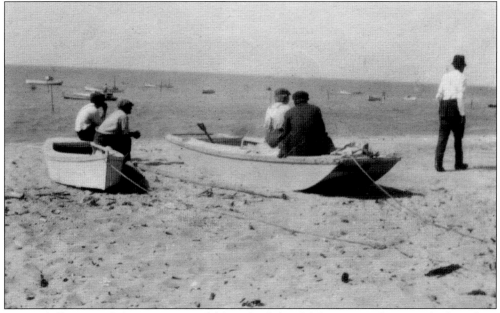

Boats of all sizes and shapes were available to both local fishermen and tourists looking for a casual outing. The shifting shoaling of the back bays was best navigated in a flat-bottom boat that sat high on the water. As can be seen in this picture, in the absence of docks, smaller boats were simply pulled up on the shoreline and tied in place above the high-tide line.

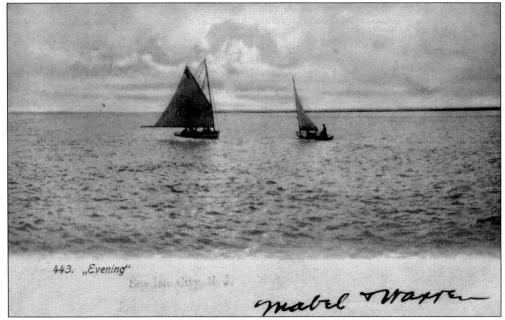

443. „Evening"
Sea Isle City, N. J.

mabel Warren

Sailing on the back bays was a popular pastime, even for an evening cruise, as shown in this c. 1906 image. A variety of small single-mast boats were commonly homemade and stored in boathouses on the mainland.

SAILING BY MOONLIGHT 57

By the 1940s, Star Class (also known as Nahant Bugs) sailboats were a common sight on the back bay. Designed by Francis Sweisguth, the Star was a gaff-rigged boat with a long boom, typical for racing boats of the day. The luff of the mainsail was 24 feet 11 inches as opposed to the 30 feet 6 inches now used on the modern rig, and the foot of the mainsail was 18 feet 4 inches as opposed to 14 feet 7 inches. Stars are still sailed competitively worldwide.

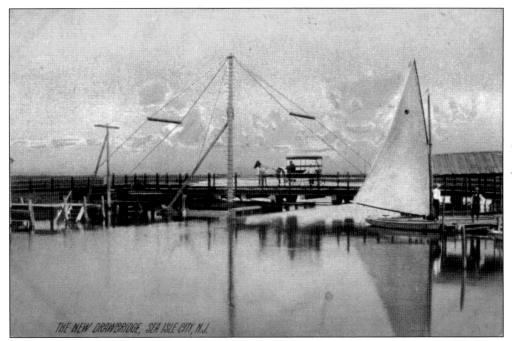

THE NEW DRAWBRIDGE, SEA ISLE CITY, N.J.

In the earliest days, the only way to reach the island from the mainland was by boat. Within a year of Charles K. Landis's purchase of the island, it was made accessible by both railroad and turnpike. A new drawbridge, pictured here around 1908, made it far easier for the sailboats and other vessels to circumnavigate the back bays.

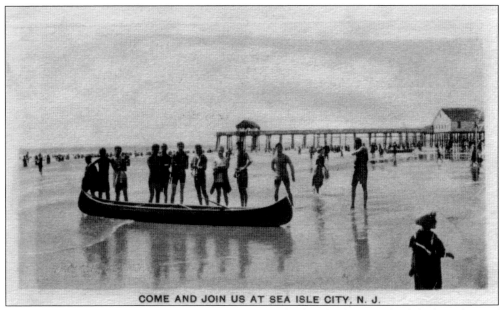

COME AND JOIN US AT SEA ISLE CITY, N. J.

Boating was not reserved to the back bays. A visit to the beach often involved the launching of a canoe into the ocean. This 1908 postcard shows a wooden canoe ready for a day in the surf.

31

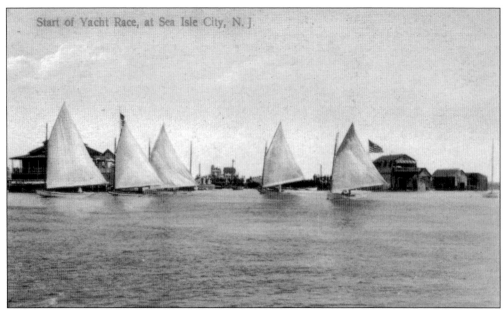

Start of Yacht Race, at Sea Isle City, N. J.

Yacht racing has a long history in Sea Isle. The city's first yacht club was built in 1910. These postcards from about 1910–1915 show the start of a sailboat race and a powerboat race. World War I restrictions on boating caused the club to close in 1918. The city did not have another club until 1941, when the chamber of commerce, under the leadership of John Pfeiffer, issued an invitation to a meeting at city hall for the purpose of organizing a new yacht club in Sea Isle City. William A. Haffert, editor of the *Cape May County Times*, had published countless editorials strongly emphasizing the advantages that such a club could provide to the community in providing a high-quality recreational area, which would offer an inducement for desirable property owners to settle in the community. The Sea Isle City Yacht Club was established in 1941 and continues to host sailing regattas as part of the Mid-Atlantic Yacht Racing Association (MAYRA) and provide sailing instruction and Coast Guard–approved boat safety courses.

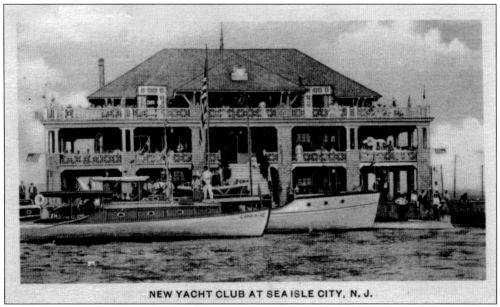

NEW YACHT CLUB AT SEA ISLE CITY, N. J.

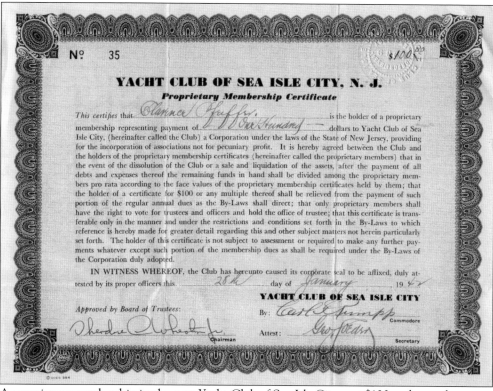

A proprietary membership in the new Yacht Club of Sea Isle City cost $100 and gave the owner the right to vote for trustees and officers, as well as hold office. Clarence Pfeiffer purchased this bond just a few years before his death.

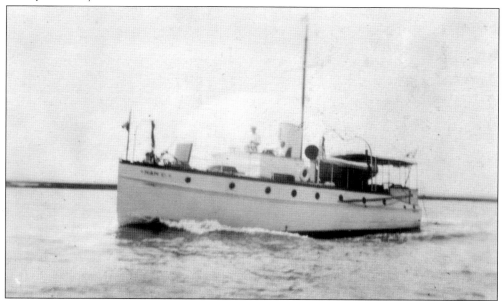

With the addition of drawbridges, the intracoastal waterways were made passable for larger power pleasure boats. The *Nan* surely provided its captain and passengers with many hours of fun on the calm waters that separates Ludlum Island from the mainland.

Sea Isle City, N. J. Sailing.

Dingy sailing was a popular pastime when this postcard was mailed home in 1907. Much like dingy racing today, these boats, with a crew of two, provide both pleasure and athletic challenge on the relatively calm intracoastal waterways.

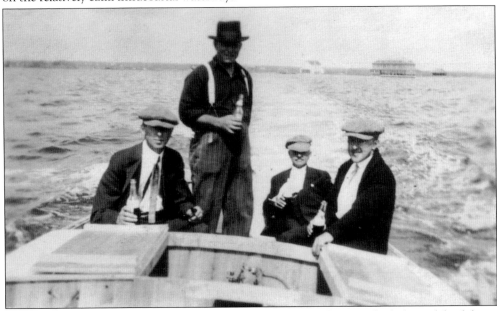

This dapper group of unidentified gentlemen most certainly does not look dressed for fishing. The long necks of the bottles in their hands lead one to wonder if they were bootleggers running beer during Prohibition. New Jersey was one of only three states not to ratify the amendment, but the federal government made it clear it would enforce the law. The Deauville Inn of Strathmere was reportedly a speakeasy during Prohibition, as well as a rum-running station. Maybe this boat made a stop there before heading out for a day on the water.

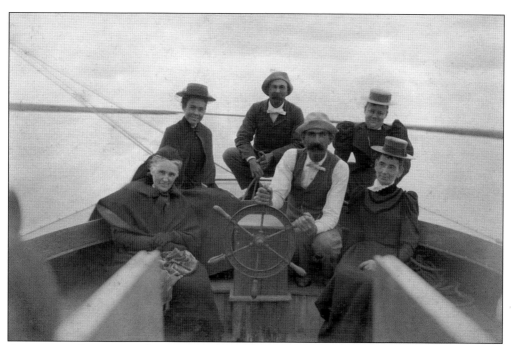

Anyone spending time in Sea Isle and Cape May County will surely recognize the surnames of this happy group of boaters. The Townsend (Townsends Inlet), the Holmes (Abigail Holmes Estate) and the Springer (Springer's Ice Cream) families all have deep seafaring roots. Hettie Springer Sayres (front row right) was the daughter of Capt. William Springer and his wife, Julia Townsend. Carrie Holmes Sayres (back row right) was the daughter of Capt. John J. Holmes and his wife, Abigail Holmes.

A day at the shore always included a pose for the camera out on the dock. Notice how the cabin in the background is built almost directly on the beach, with no protection from the water should a storm blow up.

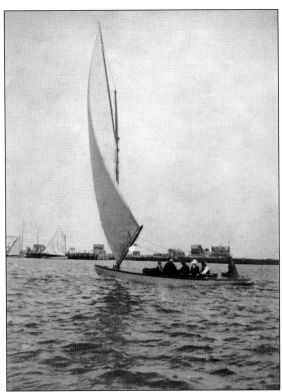

With a six-man crew, this sailboat was clearly built to hold a great deal of weight. During a race, if the air was strong, extra crew members were added as ballast to help keep the boat from overturning.

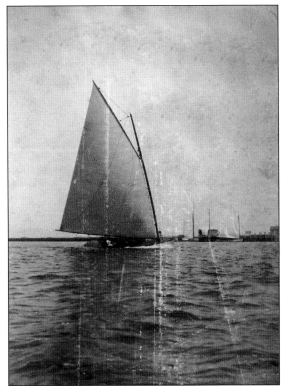

This wonderful old photograph of a dingy under full sail hints at the skill of the captain and crew. The sail is completely full of air, with no signs of luffing (collapsing of the sail due to loss of air).

Four

WHERE SHALL WE STAY?

Within just a year of Charles K. Landis's purchase of Ludlam Island in 1880, his vision of creating Cape May County's second resort was coming to fruition. An early map of Sea Isle City documents that in "only a year since Sea Isle City first started . . . it has been made accessible by railroad and turnpike, and hotels and cottages can be seen upon all sides, stretched along the beach for a mile, whilst numerous streets have been opened." When it was built in 1889, the Continental Hotel was one of the largest resorts on the Jersey coast. Located at Prospect (Twenty-fifth) Street and the beach, it had a frontage of 220 feet and a width of 400 feet, rivaling most hotels in Atlantic City. The Continental was a five-story structure with giant parlors and the only steam-operated elevator in the county. Facing the ocean, it had a beautiful view of the bay from the rear of the building. Sadly, the Continental was never a financial success, and after remaining closed for eight years, the hotel was demolished in 1921. By 1900, it was reported that there were already 30 hotels, 300 guest cottages, and a permanent year-round population of 340. Many of the early houses were moved to Sea Isle from the Centennial Exposition in Philadelphia, where they had been constructed for display as the latest in architectural design.

Visitors to Sea Isle had numerous options when it came to choosing overnight accommodations. They could stay at a boardinghouse, rent an entire house, or lodge at any one of the many hotels, offering not only rooms but also cafés and fine dining. During the day, there was the beach, boardwalk, fishing, and boating to occupy one's time. The Excursion House provided three floors of day and nighttime entertainment. Shops and a skating rink were on the first floor. The second floor was an open-air porch, perfect for watching the many beach events, including motorcycle races. The enclosed third floor housed a ballroom for dancing. Bicycle races, clambakes, sack races, and motorcycle races were sure to keep visitors of all ages occupied for a weekend, a week, or all summer long.

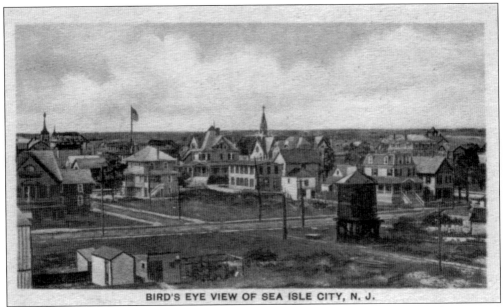

This postcard shows numerous hotels and boardinghouses, ready and waiting for the seasonal tourists who flocked to Sea Isle within just a few short years of the town's inception. On May 1, 1882, two years after Landis had started the resort, the Sea Isle City Improvement Company petitioned to make Sea Isle City a borough and elected Martin Wells as the first mayor.

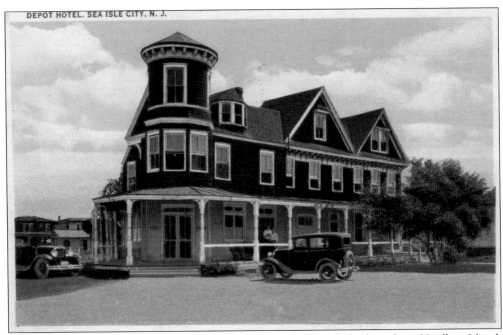

The Depot Hotel opened in 1883, just three short years after Landis had purchased Ludlam Island. Originally owned by Fritz Cronecker, it was located at the railroad station, near the current post office on JFK Boulevard. The hotel changed hands numerous times before its ultimate demise in 1938.

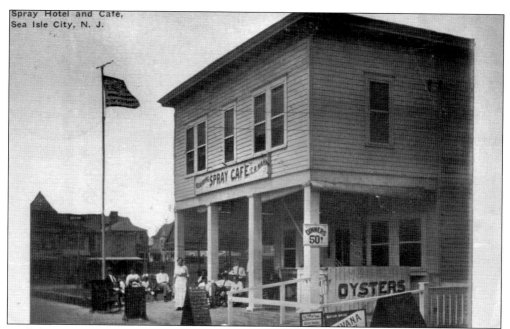

Spray Hotel and Café,
Sea Isle City, N. J.

Mailed in 1915, this view of the Spray Hotel and Café enticed those left behind in the city to join in the fun on a Sea Isle City vacation. Note that dinners were only 50¢, and oysters took center stage on the menu.

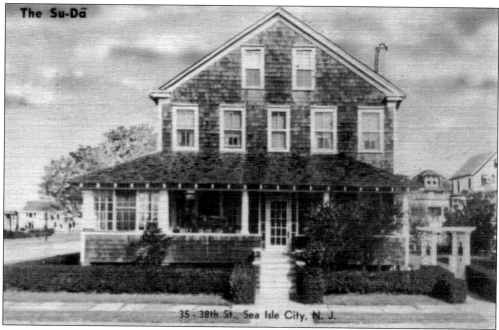

The Su-Dā

35 - 38th St., Sea Isle City, N. J.

This home at 35 Thirty-eighth Street was "our summer home" in 1953, or so the sender of this postcard declared. The covered front porch and enclosed side porch invite summer visitors to relax and enjoy the cool ocean breezes.

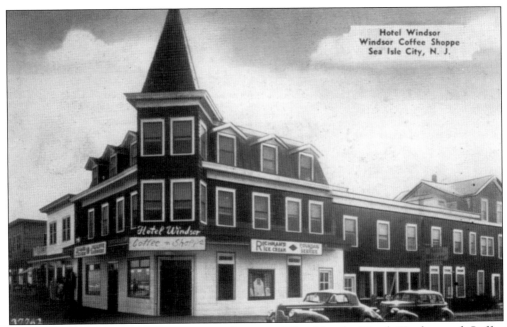

In addition to renting rooms to tourists who visited Sea Isle, the Hotel Windsor and Coffee Shoppe sold Richman's Ice Cream as well.

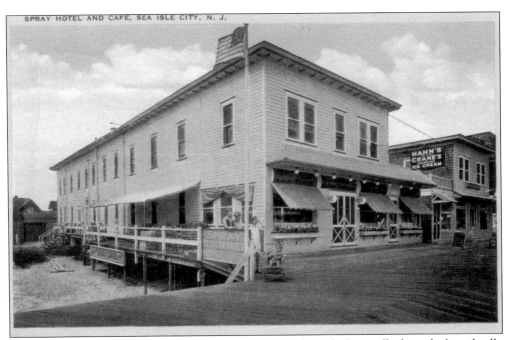

This 1930s view of the Spray Hotel and Café shows a family ready for a walk along the boardwalk. What could be more pleasant on a hot summer's day than lunch on the café's open-air porch followed by a walk along the beach while pushing the baby in a stroller? The lovely window boxes full of flowers certainly make the Spray Hotel inviting.

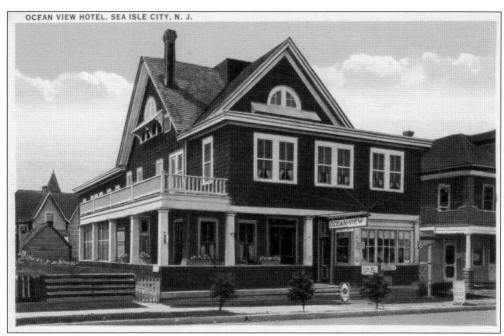

Sea Isle was not just a summer resort. The majority of hotels remained open year-round and provided a quiet getaway from city living, even during the winter months. This postcard depicting the Ocean View Hotel in the 1930s was sent in February by a young man who obviously was not enjoying the peace and quiet. He wrote, "One day here will be enough. It's dead as a graveyard."

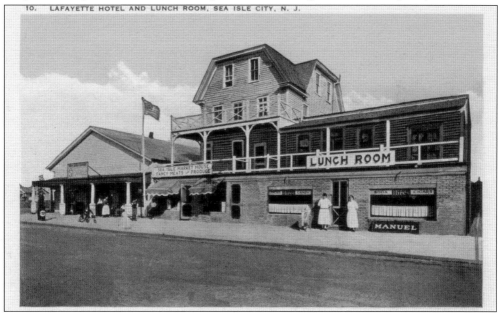

The Lafayette Hotel and Lunch Room was truly a full-service location. On the first floor, the Sea Isle Market House sold meats and produce, cigars and soda. The hotel rooms were on the upper floors, along with the requisite open porch for lounging. Without the modern convenience of air-conditioning, guests in the 1930s, when this card was mailed, depended upon the ocean breezes for relief from the summer heat.

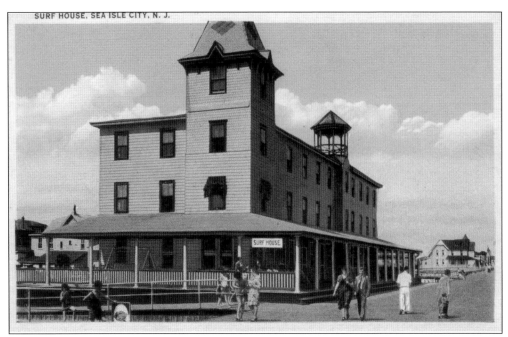

Located directly on the boardwalk, the Surf House, seen here in 1941, offered porch rockers and swings for those who would rather sit in the shade than venture down to the beach.

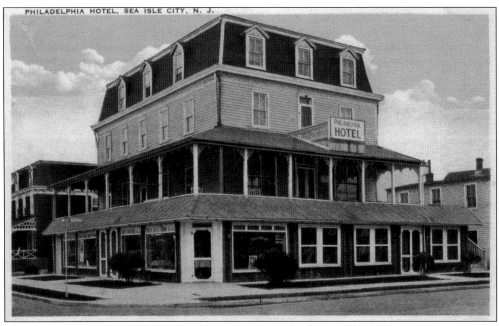

PHILADELPHIA HOTEL, SEA ISLE CITY, N. J.

While current visitors to Sea Isle may not recognize it, the Ocean Drive Hotel is just as popular now as it was in 1910 as the Philadelphia Hotel. Located at 40th Street and Landis Avenue, the hotel has always been a trendy nightspot. Affectionately known as the "OD," many a summer romance has begun, and sometimes ended, while on the dance floor.

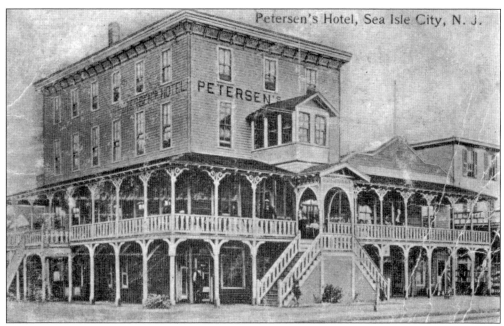

The architectural style of the four-story Petersen's Hotel was very typical of the late 1800s. Originally known as the Lincoln Hotel, the building offered wide porches where guests could spend time enjoying the cool ocean breezes. Notice that the main floor was located on the second level, lifting the guest rooms high enough to catch even the slightest breeze.

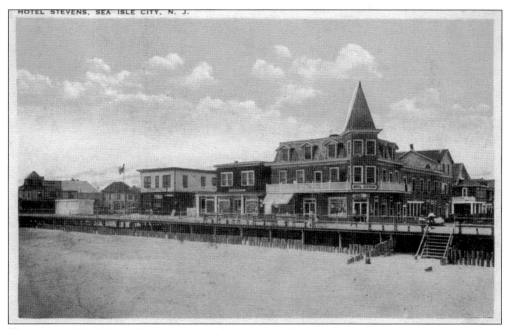

This view of the Hotel Stevens shows why its beachfront location made it such an attractive place to stay in its day. The beautiful white-sand beach was only steps from the hotel's front door. Imagine falling to sleep each night to the sound of the surf and the smell of the salt air.

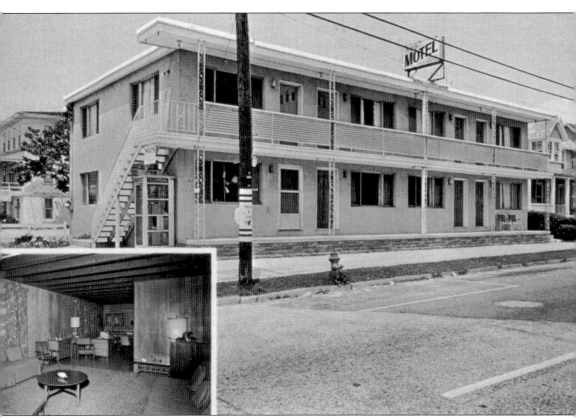

The 1950s brought the construction of "modern" motels, a concept that allowed guests to pull their cars directly up to the door of their room, for greater convenience. The Anzo Motel offered "modern efficiency units," which included a living and sleeping space, a bathroom, and a small kitchen.

Five

LET'S GO TO THE BEACH

According to *The Beach: The History of Paradise on Earth*, early Romans were devout worshippers of the beach, yet not for recreational purposes. Raw winds, invisible currents, and dangerous sea creatures kept beaches as merely the no-man's-land between the land and the sea. As an offshoot of civilization, the beach came to be viewed as pleasurable, with seaside pursuits as the lifeblood of civilized pleasures. The beach was a site of rest, meditation, collective pleasure, and boundless hedonism. However, the collapse of the Western Roman Empire in 476 AD brought an end to the beach's days as a site of overindulgence. Not until the 18th century and the era of global exploration did Europeans begin to reassess the value of the seashore.

It was the Grand Tour that, once again, helped open the eyes of tourists to the pleasures of the beach. Italy's beaches became a mandatory stopping point on the road to enlightenment and self-perfection. By the time Charles K. Landis visited Italy in the late 1870s, a day at the beach was a popular pastime, so it is perfectly understandable that, upon returning, he sought to recreate just such a travel destination in his home state of New Jersey.

An early advertisement for the Central Railroad of New Jersey noted, "Surely, there is no more exhilarating summer sport than surf bathing. The experienced swimmer knows the thrill that comes from the plunge into the surf, and even to the novice hanging on to the rope, there is a consciousness that life is better worth the living after a close communion with Old Ocean. Surf bathing under the safest and most ideal conditions is one of the potent attractions at Sea Isle City. It is a live, wide-awake place, with good hotel accommodations and many cottages to rent for the season. It has the same splendid railroad service that is given all these coast resorts by the New Jersey Central and Philadelphia and Reading Railroads." With raves like that, who wouldn't want to visit Sea Isle?

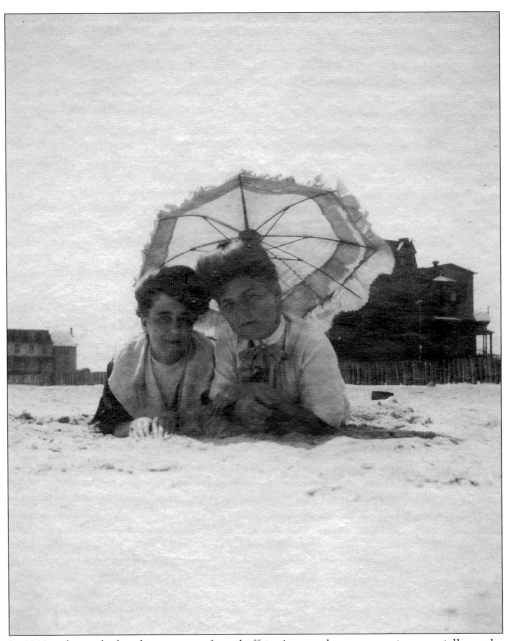

In 1902, a day at the beach was a most formal affair. A parasol was a necessity, especially on the beach, to protect the fair complexion so admired by the Edwardians. A true "lady" took great pride in her pale complexion, which she wore like a badge of honor, proving to the world that she didn't have to work outdoors like "common" females. As hat styles got smaller, parasols became all the rage, serving not only to protect the face from sun but as a flirtation tool as well. Edwardian ladies used the parasol to disguise their expression from a potential suitor, hide a longing glance from a chaperone, or coyly draw attention to themselves in a crowd. Just as hand-held fans were long used in the art of courting, coming to be known as "the woman's scepter", so the parasol became an indispensable tool to many a young visitor to Sea Isle.

The Edwardian era corresponds to the reign of King Edward VII in Great Britain, a short-lived governance from 1901 to 1910 that followed Victoria's long reign and preceded the modern House of Windsor in England. The Edwardian style broadly encompasses the years 1901 through 1919. A trip to Sea Isle offered an afternoon of genteel recreation and called for "Sunday best" attire.

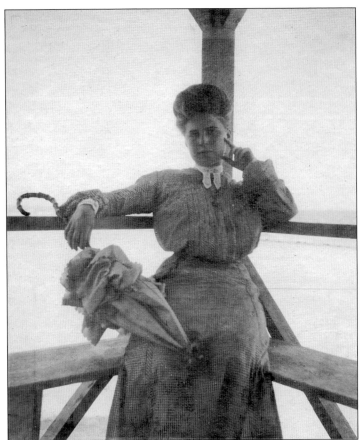

Heading to the beach did not always mean "bathing," and just as the tourists of today, these lovely ladies wanted to look their best. These visitors were dressed in the height of Edwardian fashion, with shirtwaist and skirt and, of course, a parasol. The tucking and detailed embellishments were typical of the fashionable style of the times. These two photographs and the two on the preceding pages were found in a local antique shop, framed together and hand titled as "A Day in Sea Isle, 1902."

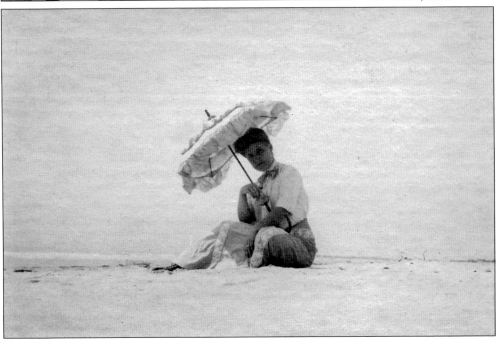

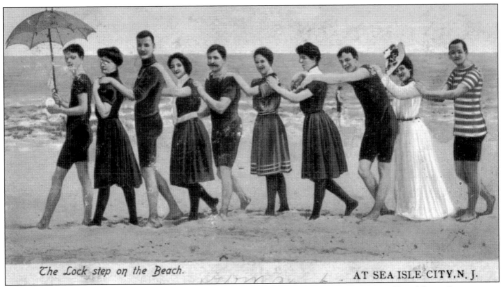

The Lock step on the Beach. AT SEA ISLE CITY, N. J.

The beach in the early 1900s offered the opportunity for the transposition of land-based activities to water. Surf dancing was just such an example. The rage for the waltz and the polka at some of the most fashionable resorts instantly spread to the surf. The gentlemen led their partners through elaborate dance steps, requiring strength, precise timing, and impeccable balance. The lockstep was particularly popular, and hotels actually set aside certain times for surf dancing, running up a red flag to announce that the beach had been reserved exclusively for this use.

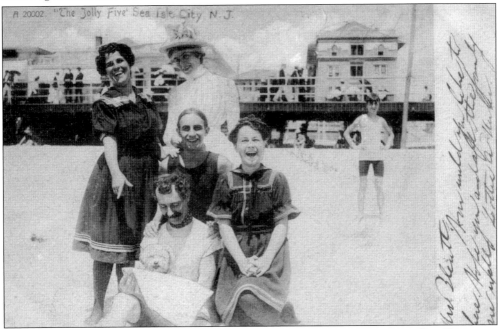

"The Jolly Five" should be "The Jolly Six" when counting the dog on the man's lap. This scene represents the bathing attire of 1906, when this postcard was mailed. Despite varieties in style and color of turn-of-the-century bathing suits, women typically dressed in black knee-length, puffed-sleeve wool dresses, with a sailor collar. Worn over bloomers or drawers trimmed with ribbons and bows, the dress was accessorized with black stockings, lace-up bathing slippers, and fancy caps.

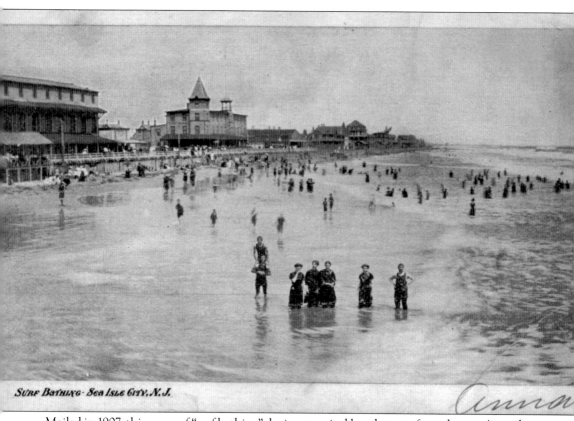

Surf Bathing - Sea Isle City, N.J.

Mailed in 1907, this scene of "surf bathing" depicts a typical beach scene from the era. According to Lena Lencek and Gideon Bosker in *The Beach: The History of Paradise on Earth*, "At the turn of the 20th century seaside life at the Jersey shore was a burlesque for the masses. Everyone was welcome, and the price of admission was the cost of a bathing suit." If swimmers didn't have their own suits, they could rent them for as little as 50¢ a day, as well as a towel for 25¢ and a locker to store clothes for an additional 35¢.

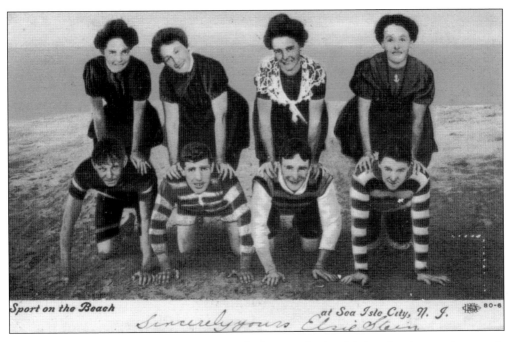

Sport on the Beach *at Sea Isle City, N. J.*

80-6

Sincerely yours Elsie Stein.

By the end of the 19th century, people were flocking to the Sea Isle beaches for popular seaside activities, such as swimming, surf bathing, and diving. Fun could be found both in the surf and on the sand, but the clumsy Victorian-style bathing costumes were becoming burdensome. A need for new attire became apparent. While still modest, the new design allowed for more freedom of movement to engage in swimming.

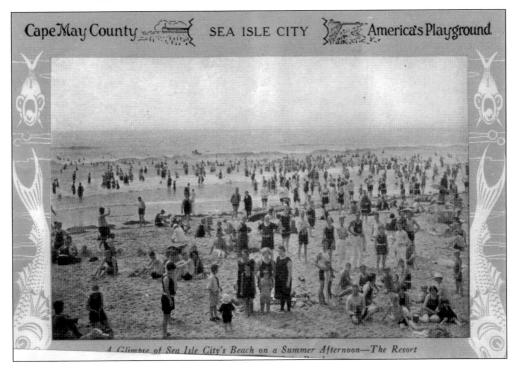

Cape May County SEA ISLE CITY America's Playground

A Glimpse of Sea Isle City's Beach on a Summer Afternoon—The Resort

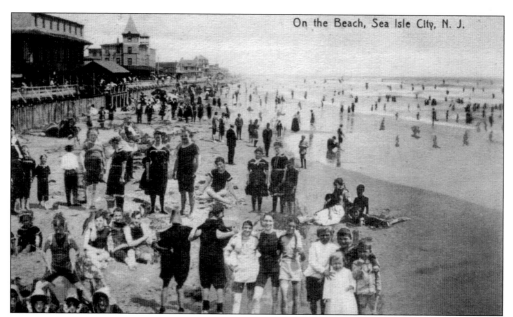

In 1909, men, women, and children alike could be found crowding the beach in Sea Isle. At the time, the beach was such a novel experience that most tourists were completely unfamiliar with the health and safety hazards it posed. Bathing guru John H. Packard, MD, a surgeon at the Episcopal Hospital of Philadelphia, cautioned anyone "who went into the water . . . to be prepared for the consequences of precipitous and prolonged exposure, which included headache . . . and nausea."

Breakers at Sea Isle City, N. J.

The ocean and the beach were the major draw for visitors to Sea Isle City. In their book *Coastlines of America*, J.A. Kraulis and Ron Watts note, "The ungraspable extent of the sea is its restlessness. Forever in motion, its waves, tides, and currents are manifest dramatically along the coast." The majesty of the Atlantic Ocean drew tourists to Sea Isle in the 20th century, just as it does today.

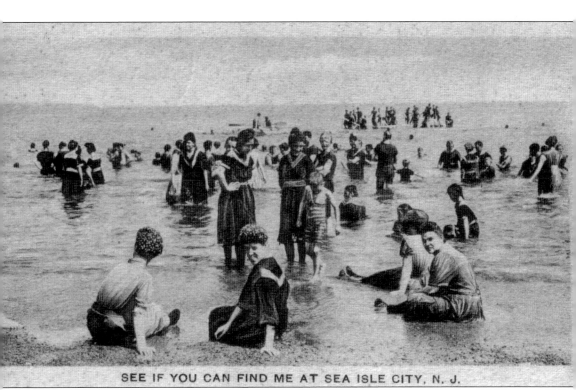

SEE IF YOU CAN FIND ME AT SEA ISLE CITY, N. J.

Wearing the bathing suits fashionable in 1913 did not lend itself to swimming, but limited ladies to wading or sitting at the edge of the water.

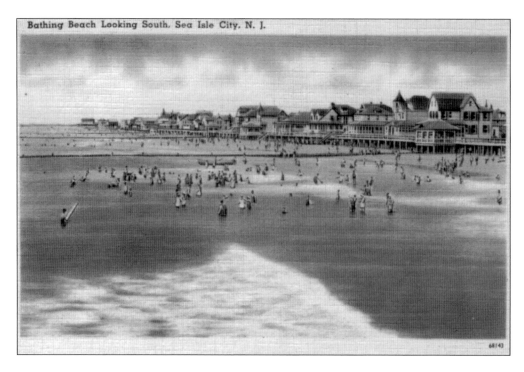

Bathing Beach Looking South, Sea Isle City, N. J.

These two Sea Isle beach scenes first look south and then north along the boardwalk. You can see the jetties built to help prevent long shore drift and therefore slow down beach erosion. Also known as groins, these wooden structures stretched out into the ocean, helping to break up the waves and calm the waters for bathers.

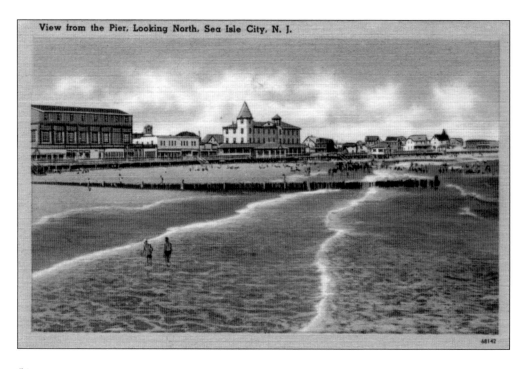

View from the Pier, Looking North, Sea Isle City, N. J.

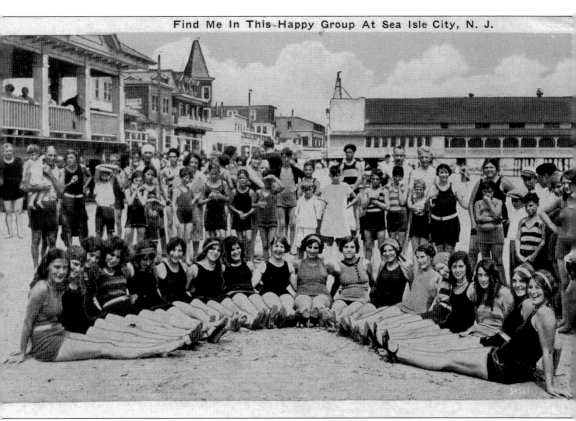

This happy group certainly seems to be enjoying their day on the beach in Sea Isle. Notice the change in the bathing suits, especially those of the women. No longer weighed down by the heavy dress-like suits of the Edwardian era, these young ladies look far more comfortable in their stylish one-piece garments with a long top covering their shorts. Though matching stockings were still worn, swimwear began to shrink, and more and more flesh was exposed from the bottom of the trunks to the tops of the stockings. By the mid-1920s, *Vogue* magazine had declared, "The newest thing for the sea is a jersey bathing suit as near a maillot as the unwritten law will permit."

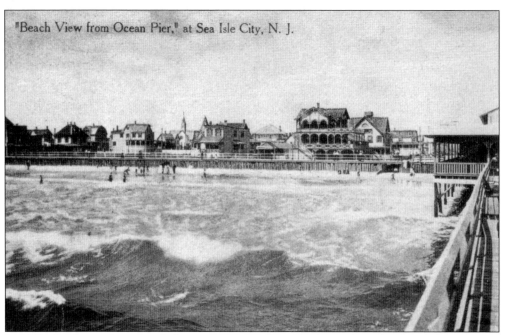

"Beach View from Ocean Pier," at Sea Isle City, N. J.

In 1912, the Ocean Pier provided access to not only ocean fishing but also the perfect place to sit and watch the surf and the people enjoying the beach. The pier was eventually renamed the Cini, then the Madelyn in 1940, when it was purchased by the Braca family and named in honor of Madelena Braca, who settled in Sea Isle in 1901.

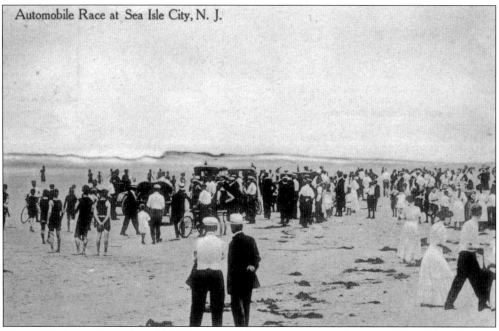

Automobile Race at Sea Isle City, N. J.

Tales of the Jersey Cape, the official bicentennial commemorative history of Cape May County, states, "Broad, flat, sandy beaches were the scene of many summer activities. There were bicycle races, beach parties, clam bakes, sack races and later in the 1920s, even motorcycle races." Here, a crowd gathers to see an automobile race in 1911.

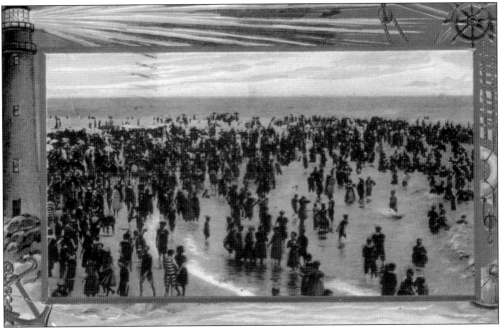

This crowded beach scene speaks to the high numbers of tourists and residents alike that flocked to the seaside each and every summer. In *The Beach: A History of Paradise on Earth*, the train trip to the Jersey Shore was described as "day-tripper delirium." Each weekend, thousands of "shoobies" were delivered to the edge of the ocean, "squinting their eyes at the glittering expanse of blue water, at the tattered lines of white foam, at the black figures flung about the surf, at the teeming, bustling, laughing, varicolored multitude of bodies swarming on the white sands."

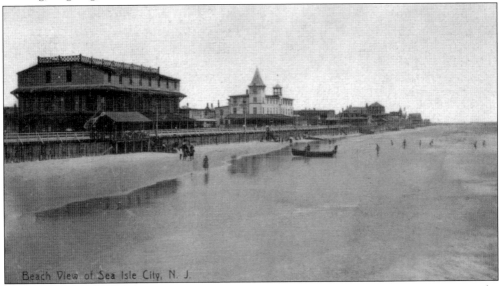

Beach View of Sea Isle City, N. J.

Written on the back of this view of the Excursion House is the following note: "Sitting in the sand at the station waiting for the train. We're having a sporty time and are as red as a berry." This message surely could have been written by any one of the thousands of day-trippers visiting Sea Isle in 1908. Notice the ornate trim along the roofline above what was once the open-air third floor.

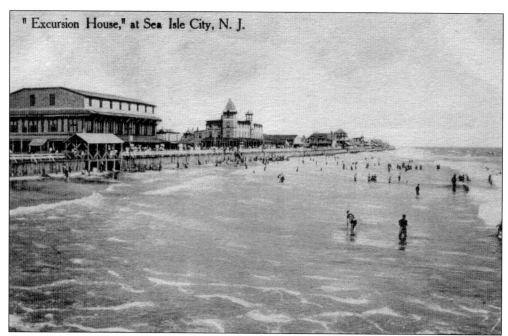

"Excursion House," at Sea Isle City, N. J.

The Excursion House was originally built in 1882 as an open pavilion and quickly became the center of social activities in early Sea Isle City. Later enclosed, it was three stories high, with stores and a skating rink on the first floor. In addition to providing space for day-trippers to eat, it boasted a ballroom, dancing school, and boxing ring. By 1910, when this postcard was mailed, the roof trim had been removed.

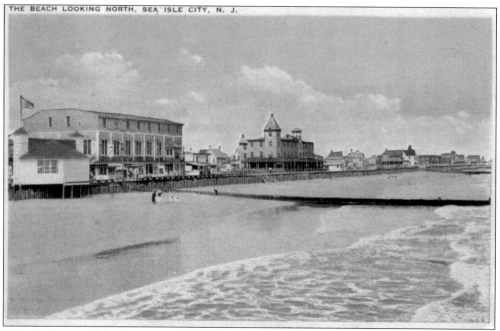

THE BEACH LOOKING NORTH, SEA ISLE CITY, N. J.

This 1923 view of the Excursion House shows a dramatic increase in the number of buildings now lining the boardwalk toward the north.

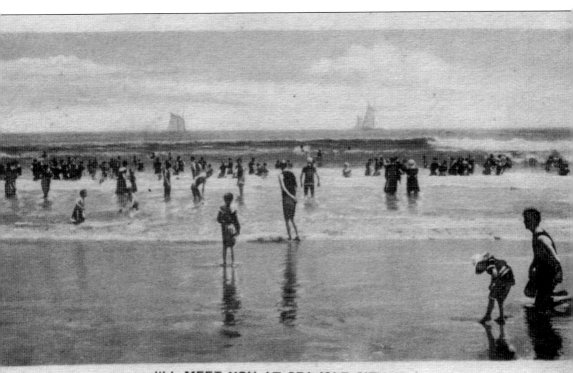

I'LL MEET YOU AT SEA ISLE CITY, N. J.

Mailed in 1915, this postcard shows not only the lovely beach but also two large schooners sailing on the horizon. Since the 1700s, schooners were used for a variety of purposes because they were fast, sleek, adaptable, and considered the sturdiest ships of all time. Seeing a schooner under full sail, paralleling the beach, was surely an exciting sight. It would not be long before these majestic sailing ships were a rare sight, replaced by steam-powered vessels.

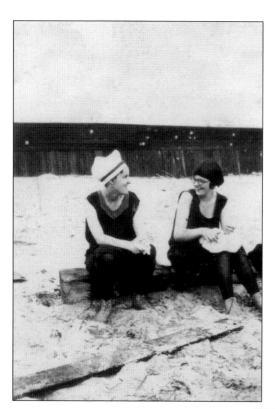

Shoes, stockings, and bathing caps complement the wool bathing suits worn by Dorothy Sayres (left) and her unidentified friend. The new bathing cap style of the 1920s was ideally suited to bobbed hair and was not unlike the cloche hat of the same era.

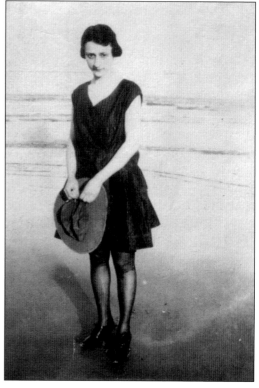

Ruth Yearick Douglass was the height of fashion in her bathing ensemble of the early 1900s. Edwardian swimsuits were very similar to earlier Victorian styles. Still made of wool, they now consisted of bloomers and a sleeveless overdress paired with black stockings and laced footwear.

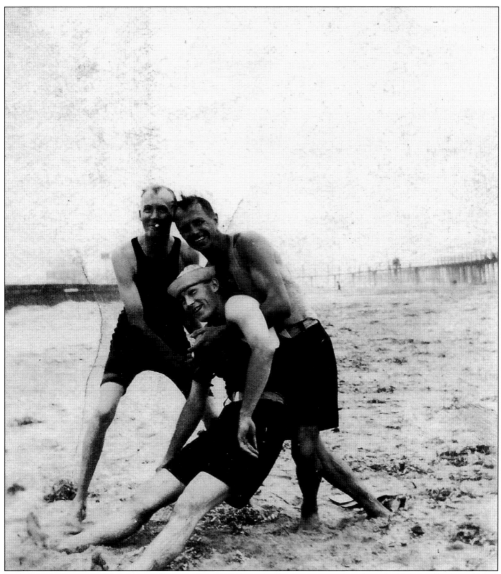

After returning from service during World War I, John Branin Douglass (right rear) joined two unidentified friends in unwinding on the beach in Sea Isle. The times were celebratory except for those mourning loved ones who would never return from combat.

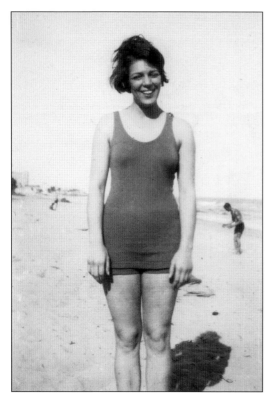

Fashion made shocking history in the 1920s with the emergence of figure-hugging swimsuits that revealed more of the limbs than ever before. Liberated from long skirts, young women of the twenties wore a wool jersey sleeveless tank suit, like the one seen here on Margaretta Pfieffer. Beneath the swimsuit legs, which stopped at an unflattering point mid-thigh, were built-in modesty shorts. Similar to male swimming costumes of an earlier era, this swimming suit was ideal for the androgynous athletic figure that fashion suited best in the 1920s. In the below picture, Margaretta (second from left) is joined by unidentified friends who show off the variety of suits to choose from. The striped suit certainly stood out in the crowd.

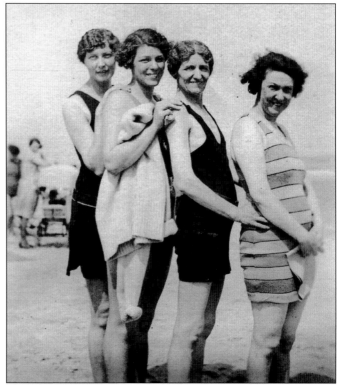

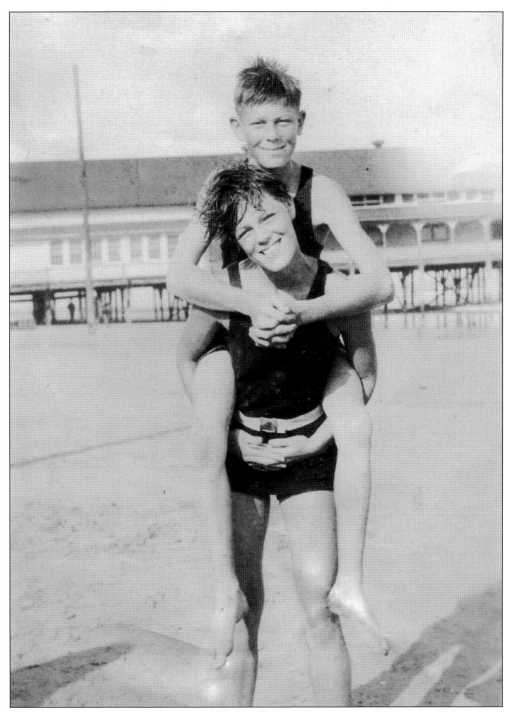

Margaretta Pfeiffer carries her younger brother John G. Pfeiffer across the sand, with the Ocean Pier in the background. Margaretta and Johnny remained very close, taking over Cronecker's Hotel and Pfeiffer's Department Store, respectively. Except for a time when Margaretta operated hotels in Florida and Johnny served in Europe during World War II, these siblings lived in Sea Isle all their lives.

Just as is the case today, a day at the beach in the 1940s always included just a little clowning around for the camera. This unidentified father and son create a strange illusion of a two-headed sea creature stalking the sand.

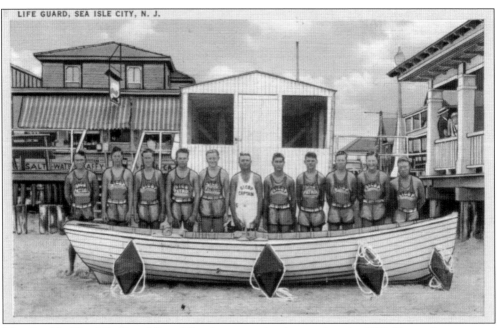

The Sea Isle City Life Guard Patrol first began paying its members in 1919. Shown here around 1930, Capt. "Jumbo" Cannova poses with his summer squad. The uniforms they wore were typical of the time period, uncomfortably made of wool. The diamond-shaped tin buoys they carried have long been replaced by far more buoyant foam rescue tubes.

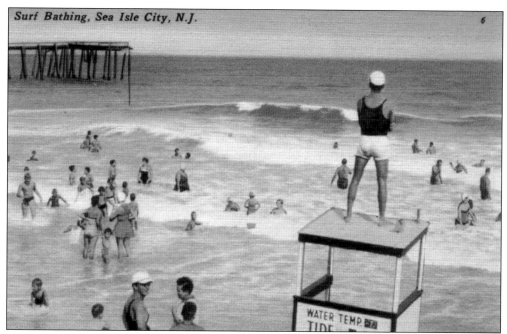

WATER TEMP
TIDE

A higher lifeguard stand provided a better view of the swimmers and, in turn, the lovely ladies in their bathing suits. Strolling the beach and showing off for the lifeguards has long been a favorite pastime in Sea Isle and the other beach communities along the Jersey Shore.

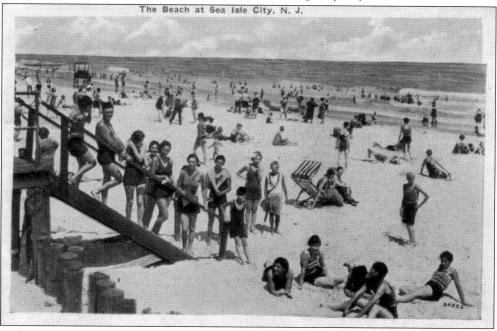

The Beach at Sea Isle City, N. J.

In the 1930s, crowds continued to flock to the beaches of Sea Isle City. Note the lifeguard stand in the distance and the rescue boat ready for launching at the edge of the surf. *Along the Shore and In the Foothills*, an advertising book printed in 1910 for the Central Railroad of New Jersey, identified New Jersey's beaches as the "summer playground of the nation." Sea Isle's beach was considered one of the safest, due to its gentle slope and lack of any dangerous undertow.

Posing on a lifeguard rescue boat, these happy children certainly appear to be enjoying their day at the beach. The reader can only speculate as to how many of these children grew up to serve as Sea Isle City lifeguards.

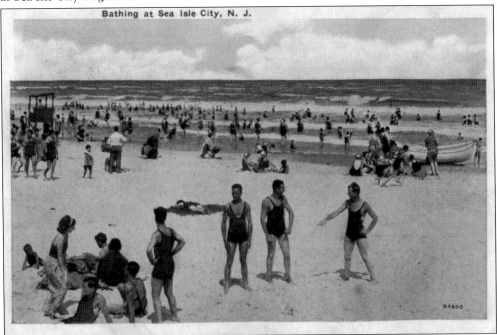

Bathing at Sea Isle City, N. J.

Mailed in 1938, this scene calls to those left at home to come "Bathing at Sea Isle City." Bathers felt safe to swim then, as they do today, thanks to the watchful eye of the ever-ready beach patrol. Current captain Renny Steele leads a select squad and sponsors an annual Mascot School for four- through eight-year-olds. Boat rides, beach and water safety, races, games, and refreshments are all part of the school's itinerary.

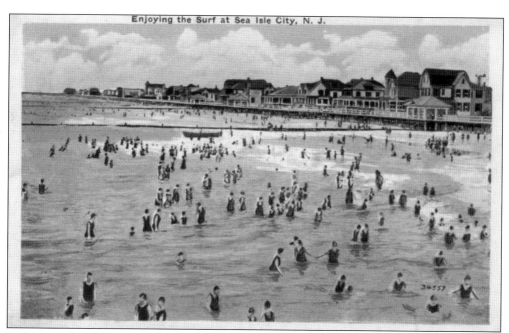

Bathing in the 1930s was no longer confined to just wading at the ocean's edge. With the more streamlined bathing suits of the era, swimmers were less encumbered by the weight of a wet wool suit and their bodies were less restricted. Note how far many of the swimmers, male and female alike, were permitted to venture from shore.

The first swim caps of the 20th century were made of rubberized fabric. During the 1920s, swim caps were made of latex and often had chinstraps, with which they were known as the aviator style because they looked like the leather helmets of airmen. John Branin and Dorothy Sayres Douglass pose in front of three unidentified friends, along with Dorothy's parents, Hester Springer Sayres and her husband, John Sayres.

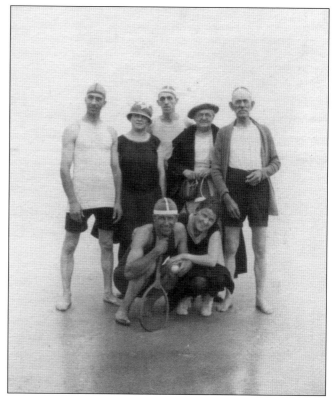

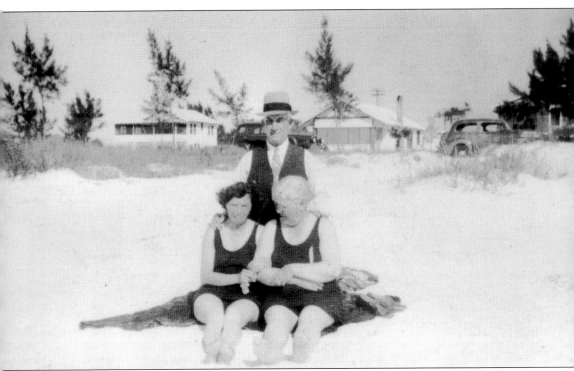

Taken in March 1936, this photograph of a well-dressed gentleman and two beach-clad ladies gives evidence to unusually warm weather during early spring in Sea Isle. These ladies do not appear to be the least bit cold as they sit on the sand, enjoying the sun.

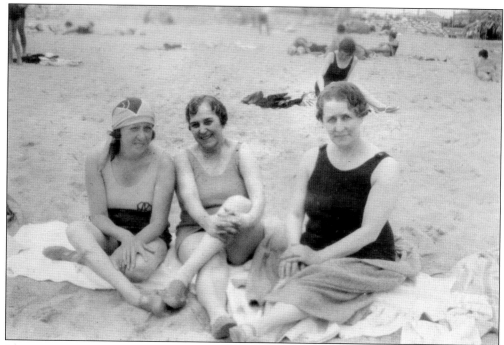

The early 1920s witnessed major progress in the transition of women's hairstyles, from the traditional long styles of the Victorian era in the 19th century to the new short styles, like the bob, worn by these unidentified ladies. The popularity of these later bobbed hairstyles continued on well into the 1930s. The tight-fitting bathing caps of the era helped to protect the curls while swimming.

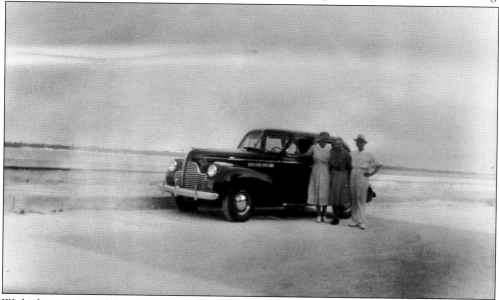

With the coming of the automobile, the train trip to the shore was rapidly replaced by that of the car. Malcolm McTear Davis described a car trip via Ocean Drive in 1955, indicating that the only interruption to the serenity was "Wildwood and its boardwalk battery of blatant amusement devices." According to Davis, Sea Isle presented "spanking sights that stretch out into the horizon as you bridge bays like . . . Townsends Inlet."

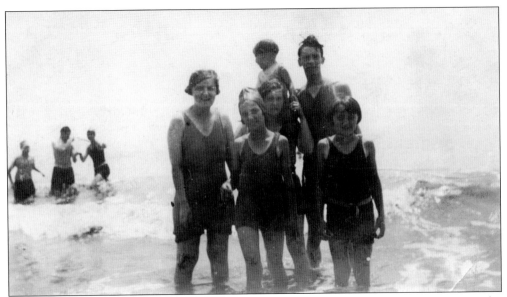

"Down for the day for a dip in the bay" was, and still is, the mantra for the many tourists who visited Sea Isle City every summer. Thousands of families have photographs like this, documenting their excursion to the beach. Dorothy Sayre Douglass stands on the left of the center group. Her companions are unidentified.

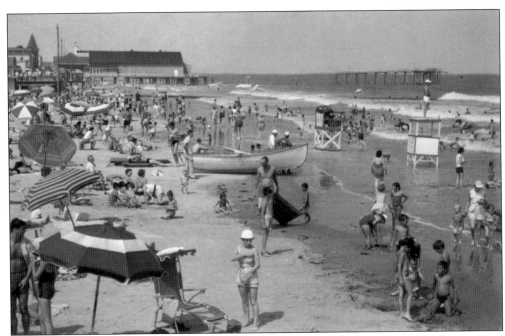

As the bathing suits of the 1950s and 1960s got smaller, the beach umbrellas got larger. Note the woman in front, applying suntan lotion and using a beach chair completely equipped with its own sunshade.

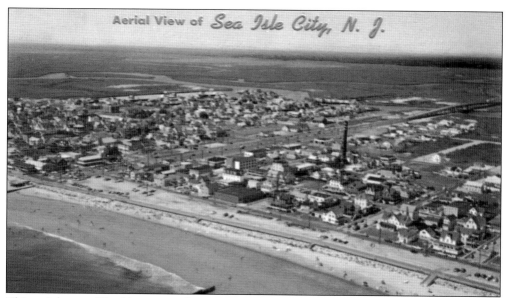

This aerial view of Sea Isle presents the community as it appeared in the early 1970s. Still recovering from the damage and destruction resulting from the March 1962 nor'easter, the beachfront stretch north of JFK Boulevard remains undeveloped, which would not remain the case for long.

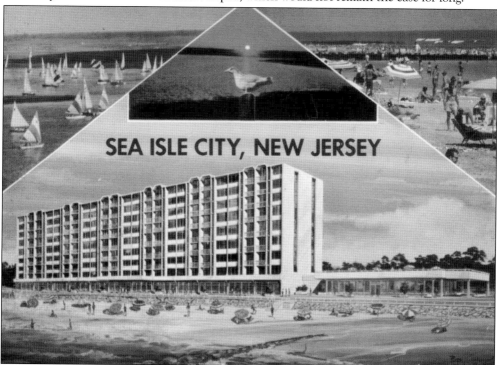

Sea Isle Investors, Ltd., conceived the Spinnaker Complex in 1972. Designed by Charles Englehart of Oxon Hill, Maryland, it was built by the Joseph Fabi Company of Atlantic City. Construction on the South Tower began in 1972. As the first "modern" high-rise condominium complex built in Sea Isle, the Spinnaker offered two- and three-bedroom units as well as the Commodore Club Restaurant at its beachfront location.

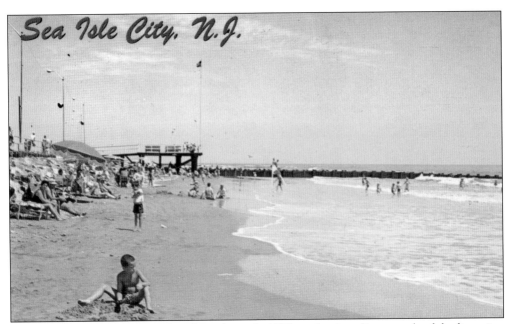

Sea Isle City, N.J.

This view of a much narrower beach in the early 1970s is clearly a direct result of the lingering effects of the March 1962 storm. Notice the rock embankment built under the boardwalk to protect the community from further rising waters.

HELLO FROM **SEA ISLE CITY,** N.J.

With the old boardwalk replaced by a modern concrete "promenade," Sea Isle spent the years approaching the 21st century reestablishing itself as a contemporary, family-friendly community. Mayor Leonard C. Desiderio has led improvements to the municipality's infrastructure, including the final phase of the Beach-to-Bay beautification project along JFK Boulevard.

Six

THE INLET COMMUNITIES

The railroad's decision to connect Sea Isle and Ocean City in 1884 resulted in the development of Strathmere, whose resort history dates back to the 1870s when it was originally known as Corson's Inlet, after early settlers John and Peter Corson. The Whelen Hotel, built in 1871, housed railroad workers and adventurous fishermen, who visited this sparsely populated stretch of barrier island. *An Historical Tour of Cape May County, New Jersey* described a c. 1930 trip south from Ocean City, as bringing "the traveler into . . . a new and ideally located resort for bathing and fishing. Proximity to Ocean City, ease of access by rail and automobile, together with the recently planned real estate improvements, will shortly make this one of the county's choicest spots of ocean playground." The narrow stretch of sand that connects Strathmere and Sea Isle is known as Whale Beach. Virtually destroyed by the March 1962 nor'easter, 50 years later state and local officials are still debating what to do with the narrow strip of sand that is one of the least-known and most dangerous stretches along the coast. The sand-starved area created by the action of waves, currents, and winds repeatedly floods in storms, has no natural dunes, and loses an average of nearly five feet of sand each year to erosion.

Townsends Inlet is actually part of Sea Isle City rather than an independent borough. In 1661, John Townsend was arrested in Long Island for his activities as a Quaker and sentenced to banishment from New York. He migrated south with his wife, son, and worldly possessions, including one yoke of oxen, one bed, and five chairs. The native Lenni Lenape Indians helped him erect a house on the mainland, near the inlet at the south end of the island. He built a dam across a swampy area covered with a stately growth of white cedar and opened a mill. Grinding grist for local farmers and sawing wood for building material soon made the mill a success. Along with the Corsons and Ludlams, the Townsends were "hardy pioneers who carved out of an uninhabited and wild country the beginning of a prosperous and well-planned county."

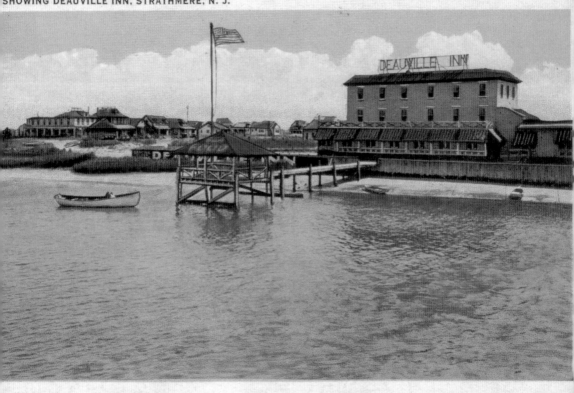

Posted in the late 1920s, this postcard shows the Deuaville Inn from the bay, just south of the Corson's Inlet Bridge. The history of the Deauville Inn can be traced through deeds back to 1887. The earliest known photograph of the inn was taken in 1888, when it was called the Whelen Hotel.

Like many young lovers, Elsie McKee and Edward Middleman Sr. spent time courting in 1930, with a boat ride on the bay in Strathmere. Elsie began traveling to Whale Beach in the 1940s in the sidecar of her brother's motorcycle. (Courtesy of the Geisser family.)

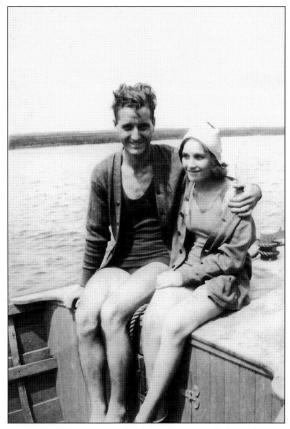

After marrying, Elsie and Edward McKee rented a cottage in Whale Beach every summer. Pictured around 1948 on the porch of their annual summer rental are, from left to right, Marietta, Edward, Harry, and their mother, Elsie. Continuing the family tradition, Marietta Middleman Geisser bought her own home in Strathmere in 1985. (Courtesy of the Geisser family.)

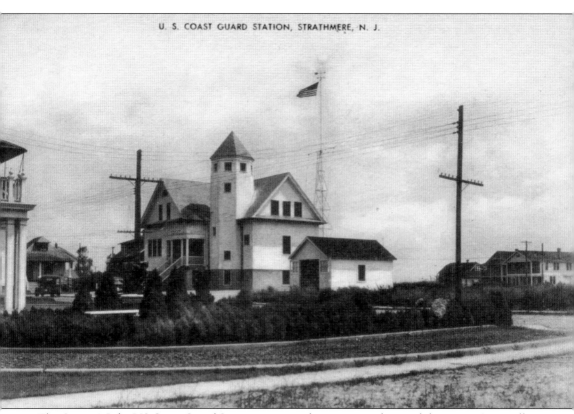

The Corson's Inlet US Coast Guard Station is pictured as it appeared around the 1940s. Originally located in Ocean City, the main body of the station was dismantled, moved, and rebuilt in Strathmere in 1924–1925. Now a private home, the station was decommissioned in 1964.

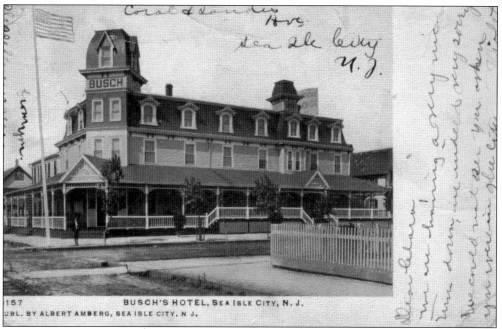

Mailed in 1907, this view of Busch's Hotel shows the 52-room establishment at its Thirty-ninth Street location. Opened by George Busch Sr. in 1882, the hotel's restaurant was added in 1912 by his son George Busch Jr. The building was sold to the Myhre family in the 1940s. The Busch family moved the business south to Townsends Inlet, where it is still in operation.

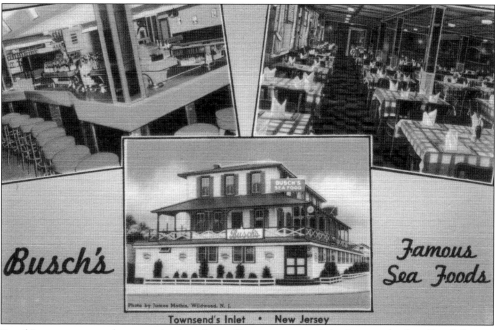

Busch's, as most people recognize it today, still serves some of the best seafood in South Jersey. The reverse of this postcard declares, "Famous for over 30 years for good food, here you will receive the finest lobsters, soft-shell crabs, [and] steaks served on the Jersey Cape. A visit here will make your vacation complete."

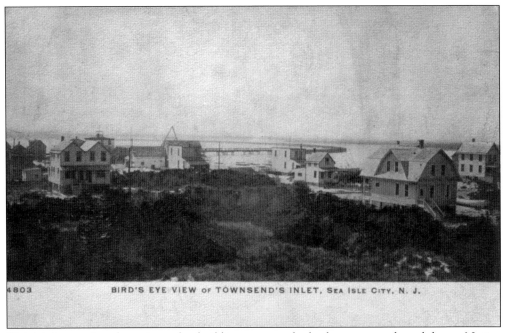

This bird's-eye view shows just a few buildings among the bayberry-covered sand dunes. Notice in particular the bridge across the inlet, leading south to what is now Avalon.

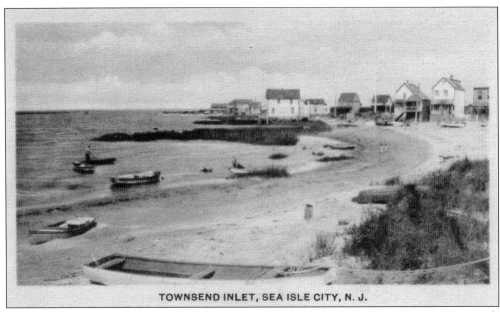

TOWNSEND INLET, SEA ISLE CITY, N. J.

This view of the back bay and inlet area is representative of the early days of coming to Townsends Inlet for relaxation and fishing. Note the small boats tied onshore, just waiting to be launched for a day on the water.

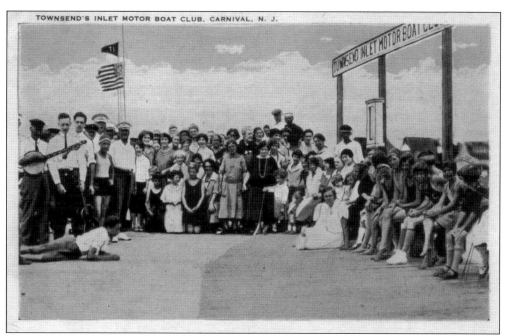

In 1934, the Townsends Inlet Motor Boat Club hosted a carnival, and most everyone in town came. On the left-hand side of the picture, note the musicians with guitar and banjo in hand. The small burgee on the flagpole sports the nickname that the town still goes by today. Even when using just the initials "TI," most folks will know it refers to Townsends Inlet.

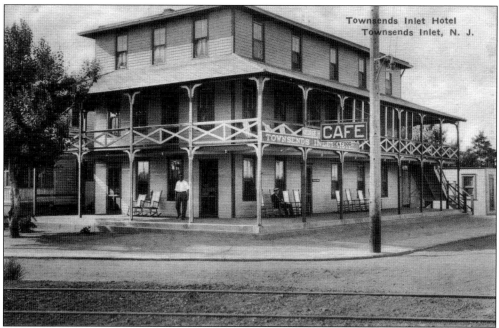

The Townsends Inlet Hotel, seen as it appeared around 1938, offered the same inviting rocking chairs on its porches as many of the Jersey Shore hotels have today. Take particular note of the two rockers to the left of the man in the white shirt; the chairs appear sized for both adults and children.

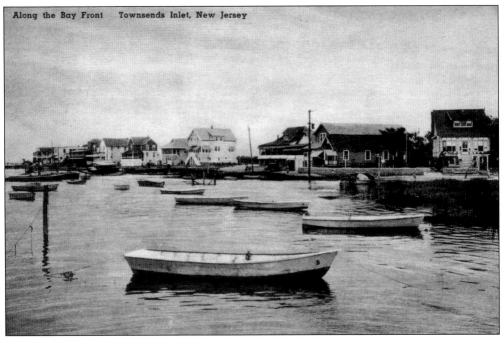

The message home in 1950 was "This is the life for Dave and I. All we do is [a] little work—eat—sleep—swim—bathe—fish—crab and go boating." Notice that none of the boats has an outboard motor, instead relying on power provided by good oars and strong shoulders.

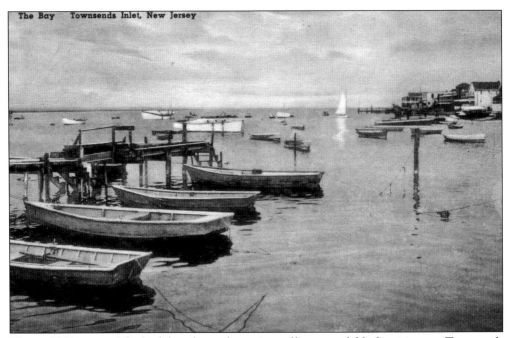

The Bay Townsends Inlet, New Jersey

This c. 1950 image of the back bay shows the variety of boats available for visitors to Townsends Inlet. Small rowboats, larger powerboats, and single-masted sailboats all share the calm waters near the inlet.

Seven

A Stroll on the
Boardwalk

In 1930, *An Historical Tour of Cape May County, New Jersey* noted that, in Sea Isle, "the tourist will find here a friendly city with a warm welcome to all the allurements of the seashore and every convenience to make your summer or winter home one of joy and comfort." A primary part of the enduring draw has been the boardwalk. Originally built in 1907, it ran for 43 blocks, yet as is not uncommon with the early wooded structures, the boardwalk was washed out by a severe storm in 1928. Costing approximately $30,000, the replacement was shorter, extending only 15 blocks. Again, in 1944, Sea Isle lost its boardwalk to a storm and rebuilt it in 1946. This time, concrete piers supported the structure. Still not content, Mother Nature struck again, destroying the boardwalk a third time in 1962. Finally acquiescing to the power of the ocean, local officials this time chose to construct a concrete-and-asphalt promenade from Fortieth to Forty-fourth Streets. Eventually extended from Twenty-ninth to Fifty-seventh Streets, the promenade is now home to several gift shops, soda shops, cafés, arcade centers, and amusement rides. The decision to reinvent the boardwalk using concrete certainly seems to have paid off. During Hurricane Sandy in 2012, the promenade suffered only minor damage.

Sea Isle's boardwalk, like the many that line the Jersey Shore, has its own culture and draw for visitors of all ages. The iconic image of boardwalk romance and summer love was immortalized in the pop music hit "Under the Boardwalk," written by Kenny Young and Arthur Resnick and recorded by the Drifters in 1964. The lyrics describe a tryst between a man and his beloved in a seaside town, where they plan to privately meet "out of the sun" and out of sight from everyone else under the boardwalk. Many summer romances have blossomed on, or under, Sea Isle's boardwalk.

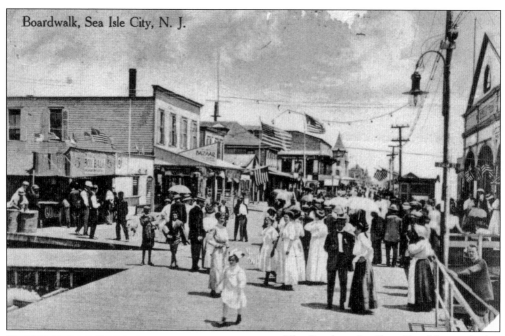

Boardwalk, Sea Isle City, N. J.

The first boardwalk in Sea Isle was built in 1907 and extended from Twentieth to Sixty-third Streets. In this c. 1912 scene, the Ocean Pier is visible on the right. Take particular note of the single-story building on the immediate left, topped by American flags. This was an American Box Ball Alley. A game of chance that could be played for 5¢, it was advertised as follows: "The most practical and popular bowling game in existence. It will make big money in any town!"

In 1916, the first Sea Isle Baby Parade began a boardwalk tradition. Margaretta Pfeiffer and her brother John G. Pfeiffer were the first winners. Captured by a concessionaire on the boardwalk, this image was found in Cronecker's Hotel in a trunk of Margaretta's belongings following her death.

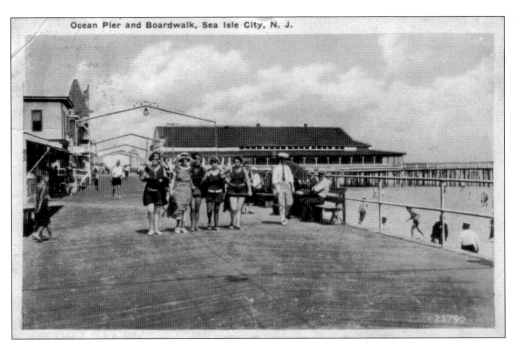

This scene from the mid-1920s shows lighting suspended over the boardwalk. The five ladies "walking the boards" sport an odd array of bathing suits and daywear. Stockings, shoes, and hats were still the required attire of the day.

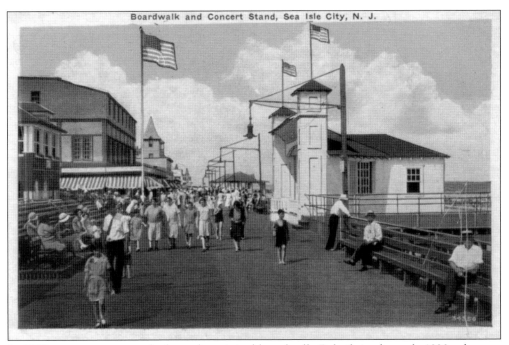

In 1928, a severe storm washed out the original boardwalk. Rebuilt in the early 1930s, the new structure included more permanent lighting.

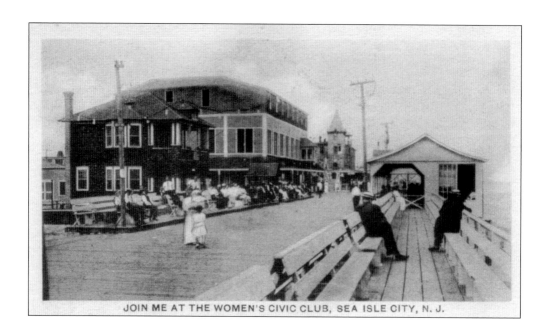

JOIN ME AT THE WOMEN'S CIVIC CLUB, SEA ISLE CITY, N. J.

The Women's Civic Club, shown here about 1915, is the oldest organization on the island. Directly facing the boardwalk, the benches invited visitors to sit and enjoy the music coming from the bandstand directly opposite. The organization is still in existence and hosts numerous social events and civic fundraisers.

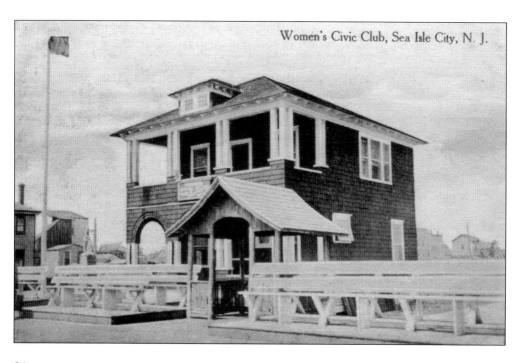

Women's Civic Club, Sea Isle City, N. J.

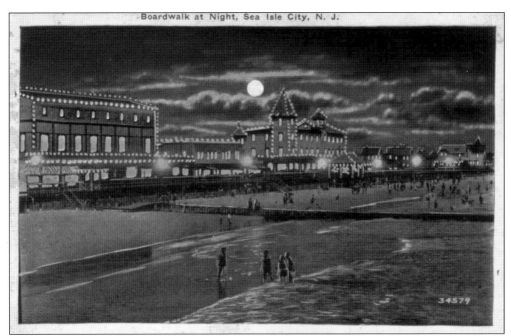

Boardwalk at Night, Sea Isle City, N. J.

Many vacation evenings were spent strolling the boardwalk, which now extended from Thirty-second to Forty-ninth Streets. Somehow, the food and fun always seemed more exotic by the glow of the lights that lined the buildings. According to New Jersey's official tourism website, the boardwalk's "initial purpose was pragmatic, intending to minimize the amount of sand trafficked into seaside hotels and train cars, but it wasn't long before the boardwalk was inserted into the public consciousness as a symbol of good times and easy living." Anyone who has spent any time in Sea Isle surely can remember a summer romance that began with a chance meeting while hanging out on the boardwalk at nighttime.

Boardwalk View by Moonlight, Sea Isle City, N. J.

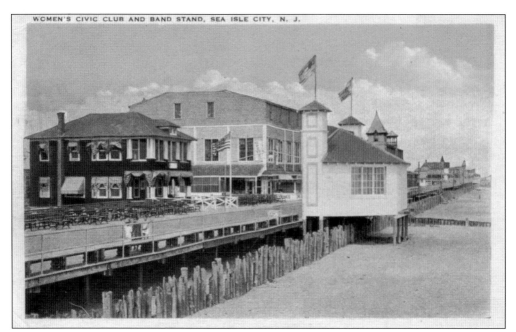

Oddly, only three children appear in this early 1920s postcard of the boardwalk, which would normally be crowded with visitors. The Women's Civic Club is on the left, with the Excursion House just beyond.

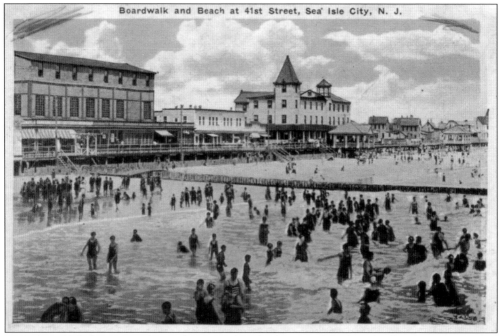

Boardwalk and Beach at 41st Street, Sea' Isle City, N. J.

Mailed in 1936, this postcard provides a great beachside view of the boardwalk. The now enclosed Excursion House sports storefronts facing the boardwalk, enticing tourists to purchase souvenirs of their trip. Notice that the beach does not appear as wide in this view as in earlier years, most likely the result of storm erosion.

This unidentified couple appears so caught up in smiling for the camera that they are oblivious to the child climbing just above their heads. Half the fun for children at the beach was exploring, whether in or out of the ocean. Searching under the piers and around the jetties has provided hours of entertainment for generations of curious children.

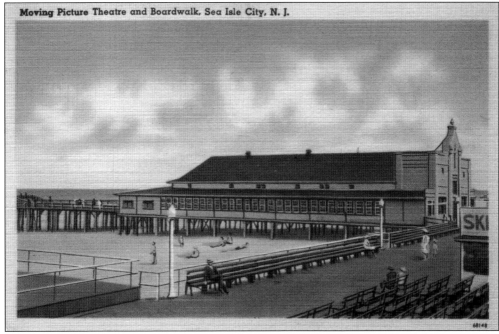

Moving Picture Theatre and Boardwalk, Sea Isle City, N. J.

By the 1940s, the Ocean Pier housed a motion picture theater. Hollywood film production reached its profitable peak of efficiency during the years 1943 to 1946. Advances in film technology—sound recording, lighting, special effects, cinematography, and use of color—meant that films were more watchable and "modern." *Casablanca* was sure to have been a hit with visitors to Sea Isle.

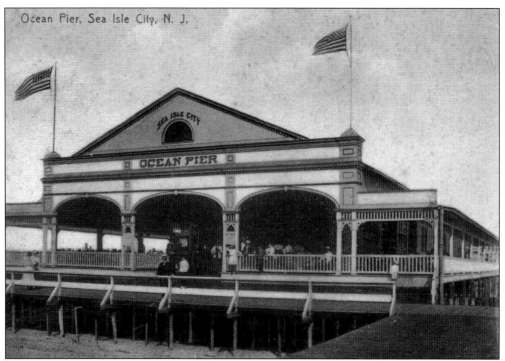

The Ocean Pier was built in 1907, between Forty-first and Forty-second Streets. Extending out over the beach to well beyond the shoreline, the pier was such an imposing presence that it appears in many photographs and postcards picturing Sea Isle's beach. The open-air portion of the pier provided tourists with the perfect vantage point for watching the crowded beach below, while the covered pavilions at the ocean end of the pier protected fishermen from the burning rays of the summer sun.

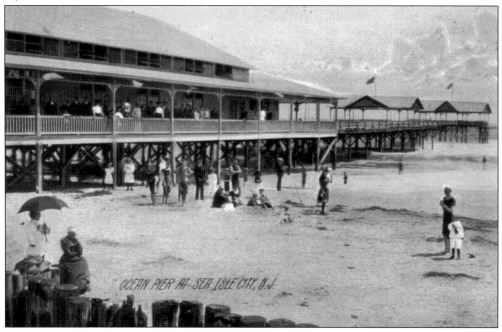

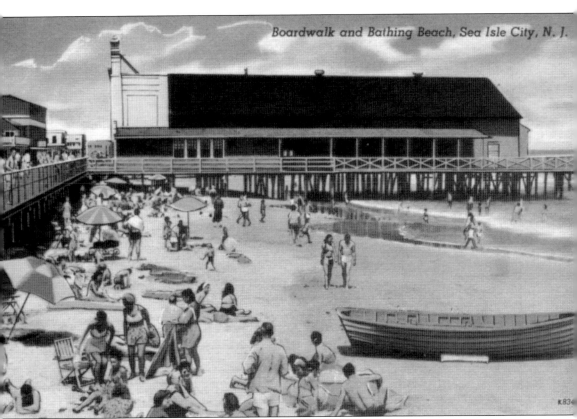

Boardwalk and Bathing Beach, Sea Isle City, N. J.

K834

This postcard depicts the Ocean Pier after it had been badly damaged by the Great Atlantic Hurricane, the first time a name was designated by what would become the National Hurricane Center. The hurricane hit the Jersey Shore with a strong and destructive glancing blow on September 14, 1944, before making landfall on Long Island as a Category 3 hurricane. The storm was infamous for the amount of damage it caused along the New Jersey coastline.

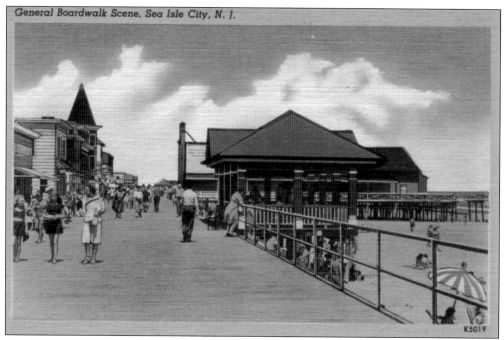

In addition to movies, visitors could enjoy live music performances from the boardwalk pavilion on the beach side of the boardwalk. During the day, it was not only a place to sit and escape the sun, but it also provided a great place for children to play. Notice the many people relaxing "under the boardwalk."

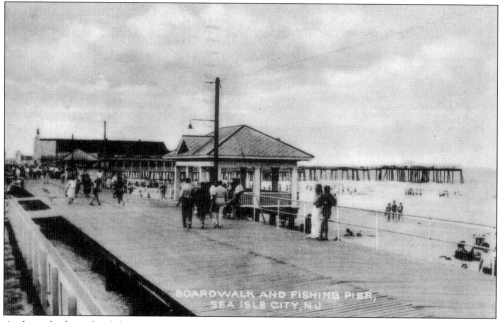

A closer look at the fishing pier extending into the ocean shows the loss of the roofed pavilions during the 1944 Great Atlantic Hurricane.

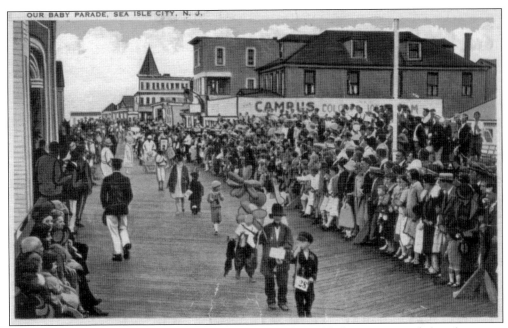

Sea Isle City's first Baby Parade was held in 1916 and quickly became a much loved summer tradition. The chance to win prizes in separate divisions, including "most attractive baby under two," children in fancy strollers, fancy dress, comic, and floats have attracted thousands of participants over the years. The 2012 parade featured live music, fire trucks, the color guard from VFW Post 1963, elected officials, and a float carrying the contestants from the Little Miss & Junior Miss Sea Isle City Pageant. Hosted by the city's tourism department, the Baby Parade is a yearly event that was originally organized by Sea Isle's Women's Civic Club. Today, it is more popular than ever, thanks to the many smiling children who participate each year.

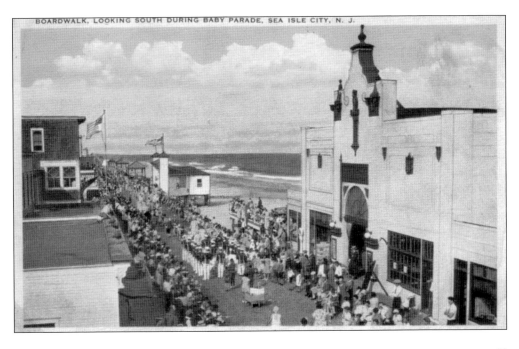

Beach attire had changed dramatically by the late 1950s. The woman pictured in the center of this postcard is wearing the latest in bathing suit fashion—a yellow polka-dot bikini. So popular, it inspired a novelty song, "Itsy Bitsy Teenie Weenie Yellow Polka Dot Bikini," telling the story of a shy girl wearing a revealing bathing suit at the beach. Written by Paul Vance and Lee Pockriss, the song was released in June 1960 by Brian Hyland, with orchestra conducted by John Dixon.

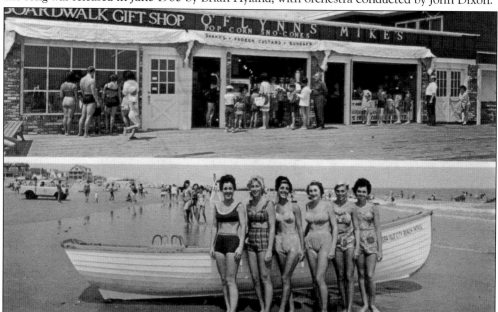

O'Flynn's and Mike's were just two of the many food vendors on the Sea Isle boardwalk. Popcorn, snow cones, milk shakes, frozen custard, sundaes, and French fries were traditional treats, readily available to beach and boardwalk patrons. With all those tempting indulgences, one has to wonder how the six ladies posing in front of this rescue boat about 1960 kept such great figures!

Eight

SHOPPING AT PFIEFFER'S DEPARTMENT STORE

In the book *Sea Isle City, New Jersey: A History*, the authors point out that, being located near the ocean and inland waters as well as close to farms offshore, early residents of Sea Isle could usually get sufficient food, but fuel, clothing, and other necessities were hard to come by. Obviously, there was a need for mercantile establishments to provide daily necessities if residents were to be able to remain on the island on a year-round basis. Clarence Pfeiffer and his wife, Caroline (née Cronecker), saw this as a great opportunity. They opened their first mercantile store at 4208 Landis Avenue, between Forty-second and Forty-third Streets. A true general store, they sold everything from nails and building supplies to tennis rackets and rugs. Built in 1914, the store was located in the front of the building, with living quarters in the rear and on the second floor. As the community grew, so did the need for expanded shopping. The Pfeiffer family purchased the lots directly north of the original store and built a much larger two-story building, again combining the store with living quarters for their family. The first floor of the store carried hardware and household goods and was eventually franchised as an Ace Hardware store by their son John G. Pfeiffer. A small room to the left of the main floor was the lingerie department, selling silk and nylon stockings, nightgowns, ladies gloves, and hankies. The second floor carried women and children's clothes, with the well-known Janzen brand being predominant.

What most visitors to the store never got to see was the Pfeiffer family's large and beautiful home, connected to the store through a doorway in the office. An eat-in kitchen, formal dining room, and large living room with a fireplace graced the first floor. A side door off Landis Avenue, between the new building and the original 4208 location, served as the main entrance to the home. The second floor contained three bedrooms, a dressing room, a bathroom, and a large sitting room that extended across the entire width of the building, facing Landis Avenue.

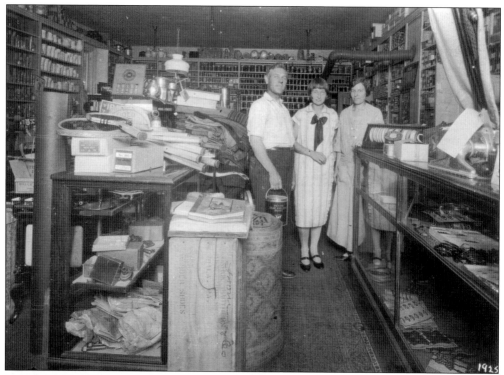

The original Pfeiffer's Department Store is shown in this 1925 photograph of owner Clarence Pfeiffer and his wife, Caroline Cronecker Pfeiffer. The young woman pictured with them is not their daughter, Margaretta, but a friend, Margaret Tolson.

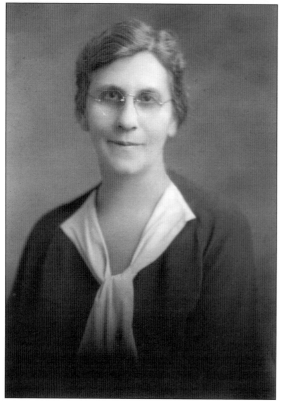

The marriage of Clarence Pfeiffer to Caroline Wilhelmina Cronecker united two of the most influential families in Sea Isle's past. When they died in 1945, their son John G. Pfeiffer was granted a release from the Army. The letter to the US Army requesting this release stated that the store "carried supplies for all the builders, carpenters, masons, and plumbers in this area, and represents an important business in the economy of this community."

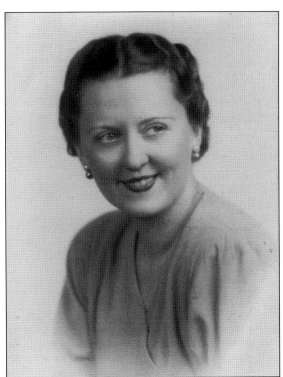

John G. Pfeiffer and his wife, Eleanor Erricson Pfeiffer, met during one of her many summers in Sea Isle and married shortly after his return from World War II. They teamed up to operate Pfeiffer's Department Store until their retirement in 1989. Sadly, John died following surgery shortly thereafter. Eleanor was the great-granddaughter of George Sayres Sr., one of the early officers in charge and keeper of US Life Saving Station No. 33.

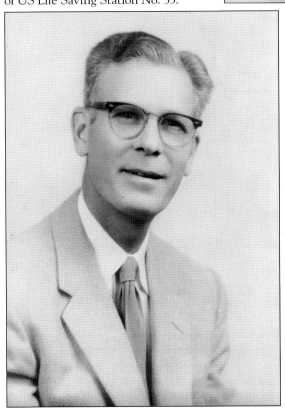

SEA ISLE CITY • NEW JERSEY
08243

JOHN G. PFEIFFER, OWNER (609) 263-8632

Running Pfeiffer's Department store became a lifelong endeavor for John G. Pfeiffer. This blue-and-white business card proudly displays the recognizable Pfeiffer's logo that featured prominently on all their advertising. Large roadside billboards appeared on the mainland, enticing visitors to shop in the largest store in Sea Isle.

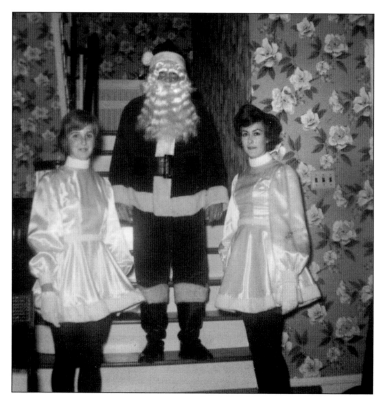

Each November, the second floor of Pfeiffer's Department Store went through a major transformation, turning the space normally reserved for women and children's clothes into a Christmas Toyland. Santa and his elves would do their magic, and every child in town would come to look at all the toys, trying to decide which should go on his or her wish list for Santa. This photograph was taken on the staircase in the Pfeiffer's home, which was connected to the store.

The old saying "like a kid in a candy store" could easily apply to the authors' time at Pfeiffer's Toyland. The store was always closed on Sundays, which provided the perfect opportunity to try out all the toys. Bikes, trikes, wagons, and pedal cars were often driven up and down the well-worn wooden floors of the second floor. The Sunday before Christmas was always reserved for a family trip to visit Pfeiffer's and Aunt "Orney" Eleanor and Uncle Johnny, who would let relatives and close family friends spend hours in the toy department, making their list for Santa.

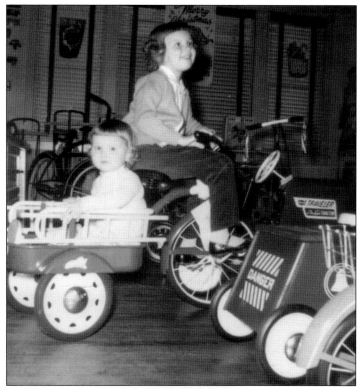

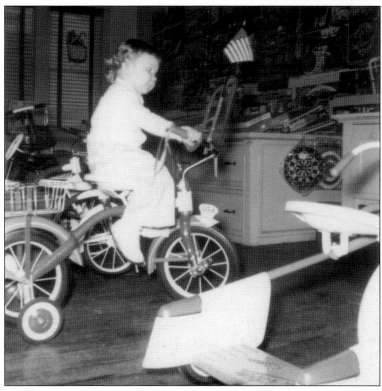

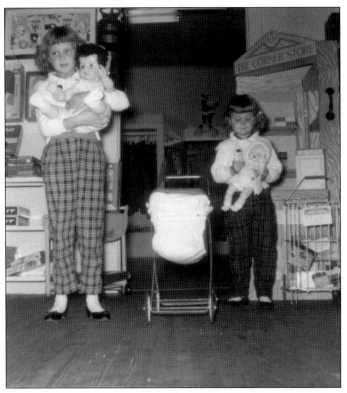

Display cases held Madame Alexander, Chatty Kathy, and Shirley Temple dolls. Games and stuffed animals, toy cars and trucks, and even puppet stages would suddenly appear in place of the bathing suits, shorts, skirts, and slacks. A doorway from the second-floor living space provided easy access to Toyland, and even as customers were making their final purchases downstairs at the front register, those lucky enough to be given private access to Toyland would be creeping through this often unnoticed doorway, feeling every bit as special as children of royalty. Just the anticipation of a private excursion into Toyland was enough to keep boys and girls dreaming for weeks.

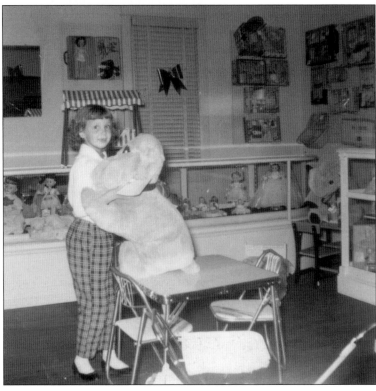

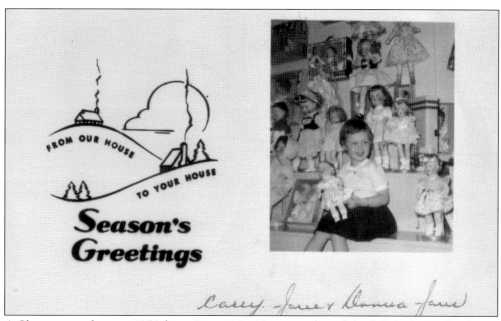

Season's Greetings

FROM OUR HOUSE TO YOUR HOUSE

Larry, Jane & Donna Jane

A Christmas card sent in 1956 shows Donna Van Horn seated amid the doll display. Dolls of every shape and size were available to shoppers from Sea Isle and the surrounding communities. In addition to the toys for sale, John G. Pfeiffer had an extensive toy train collection that he put up each year as part of the holiday display. Boys and girls alike would be mesmerized, watching the trains travel through the make-believe town while their parents shopped for their Christmas gifts.

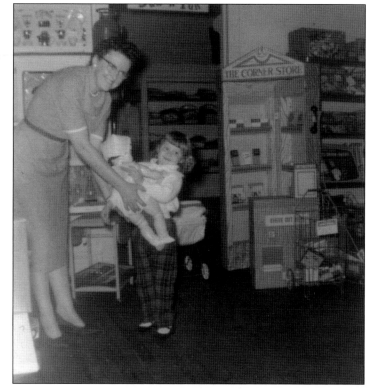

After a day of private play in Toyland, Eleanor Pfeiffer would make her own Christmas shopping easy by simply permitting each family member to choose one toy to keep as his or her Christmas gift. As could be expected, this decision could take another few hours, as each toy was revisited and reevaluated before the final decision was made. Here, Eleanor gives Karen Jennings a Madame Alexander life-size talking doll, almost too big for her three-year-old arms to carry. A prized possession, the doll remains in the author's collection.

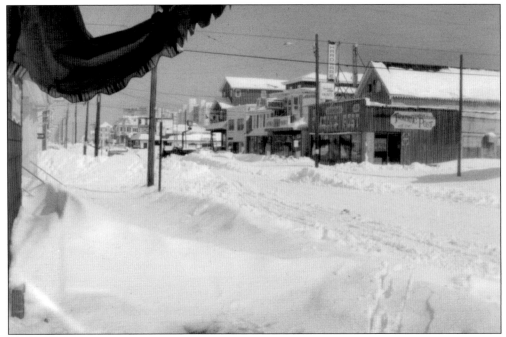

In 1979, a nor'easter turned Landis Avenue into a real winter wonderland. Snow this deep does not often hit the coastal communities since the warm air off the ocean helps to keep snow from forming. Looking north from the front of Pfeiffer's Department Store, Creighton's Trading Post is visible on the opposite corner. As is typical with a coastal snowstorm, the strong ocean winds caused large drifts to build right in front of the large display windows of Pfeiffer's Department Store. Traffic came to a standstill, and the best way to get around was by foot.

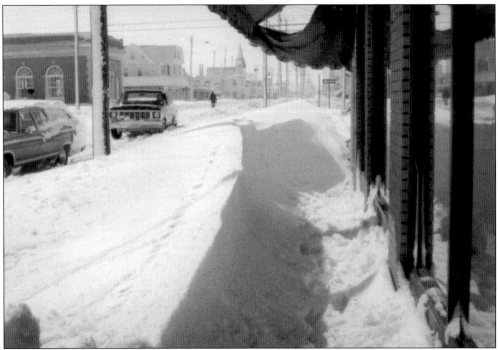

Nine

MEET ME AT CRONECKER'S HOTEL AND RESTAURANT

Any developing resort attracts entrepreneurs willing to invest "on the ground floor," in the hopes of establishing both a profit and a personal connection to the community. Joseph Friedrich "Fritz" Cronecker and Margaretha Carolina Lautenschlager Cronecker were just that breed of businesspeople. They began their connection to Ludlam Island with the opening of the Fritz Cronecker Depot Hotel in 1883. Located near the train depot, it was one of the first hotels a visitor traveling by train would see upon disembarking. Business was good, but just like today, tourists sought proximity to the beach. In 1887, they opened a much larger hotel, Fritz Cronecker's Bellevue Hotel, just a block from the beach. An advertisement from the Central Railroad of New Jersey described the hotel and its location as follows: "One square from the Boardwalk. Oceanview. Home comforts. First-class cafe. Steam heat. Electric light. Rates $2 per day; $10 per week upwards. Open all the year."

For the next 78 summers, Cronecker's Hotel and Restaurant, as it came to be known, was one of Sea Isle's oldest and best-known landmarks. Cronecker's was the stopping-off place for some 10,000 guests annually and long retained its 19th-century flavor, including a trough of running water at the foot of the bar for cigarette and cigar butts. Because the building was continuously owned and operated by members of the family until its demolition in 1965, few modern conveniences were ever installed. The lack of elevators, air-conditioning, or other conveniences never seemed to keep guests from coming back year after year. As noted in one local newspaper that chronicled the demolition, the hotel's reputation rested on "something more solid—fine accommodations and excellent food." It was not just Cronecker's Hotel that left an indelible mark upon Sea Isle City. Fritz and Margaretha had eight children, and two of their sons eventually served as mayor. Richard W. Cronecker served from 1917 to 1919, and his brother G. Fred Cronecker served from 1937 to 1945.

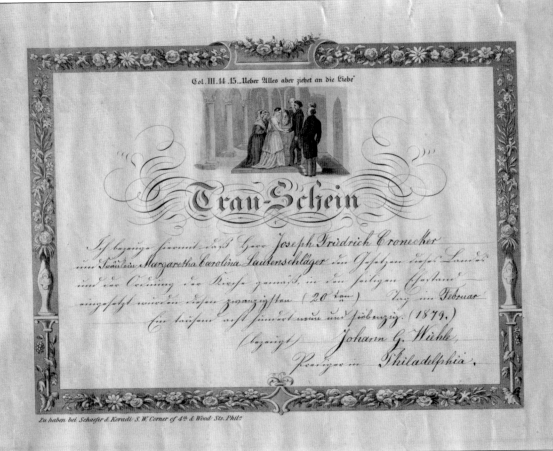

This is the marriage certificate issued to Joseph Friedrich Cronecker and Margaretha Carolina Lautenschlager in Philadelphia, Pennsylvania, on February 20, 1879. Notice that even though the document was issued in the United States, it is printed in German. The Croneckers were just a few of the many German immigrants who came to early Sea Isle City seeking their fortune. They opened their first establishment in Sea Isle City, the Depot Hotel, just four years after their marriage.

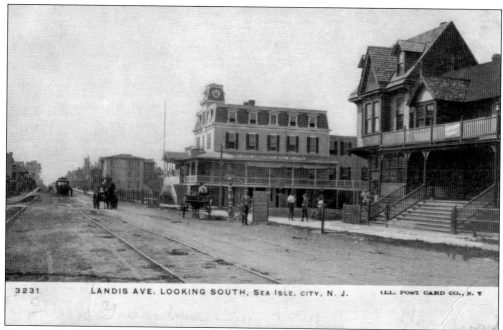

3231 LANDIS AVE. LOOKING SOUTH, SEA ISLE, CITY, N. J. ILL. POST CARD CO., N. Y

Postmarked 1905, this postcard shows Landis Avenue looking south. This early view of Cronecker's Hotel Bellevue shows not only the trolley heading north on Landis Avenue but also horse-drawn carriages and people on bicycles. Clearly, there were numerous options for getting around the rapidly developing city.

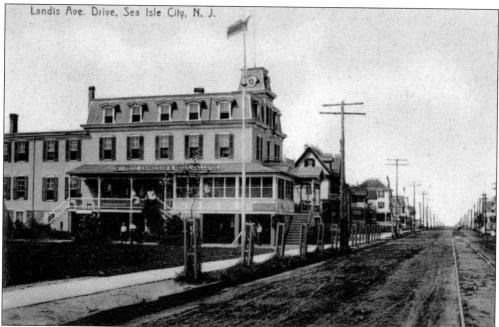

Landis Ave. Drive, Sea Isle City, N. J.

Looking north on Landis Avenue in 1909, Mrs. Fritz Cronecker's Hotel Bellevue greeted guests to Sea Isle with the best in South Jersey hospitality. Notice that Landis Avenue remained relatively unpaved, with the trolley running down the middle of the street. Passengers could easily hop on the trolley and ride the length of the island.

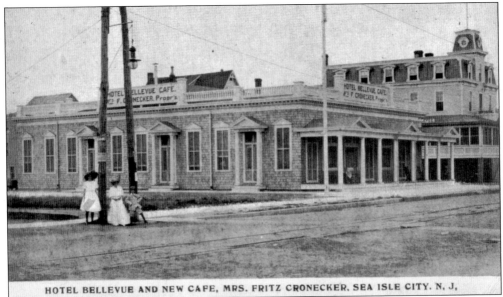

HOTEL BELLEVUE AND NEW CAFE, MRS. FRITZ CRONECKER, SEA ISLE CITY, N. J.

By 1914, Margaretha Cronecker had added a new dining room to the south side of the hotel. Now called the New Café, this addition housed a large elegant bar in the front and a huge formal dining area in the back. The bar area was decorated with a massive collection of beer steins, imported from Germany. While many of these steins disappeared over the years, thought to have become "souvenirs" for some of the more daring guests, the remainder are now in the personal collection of the author.

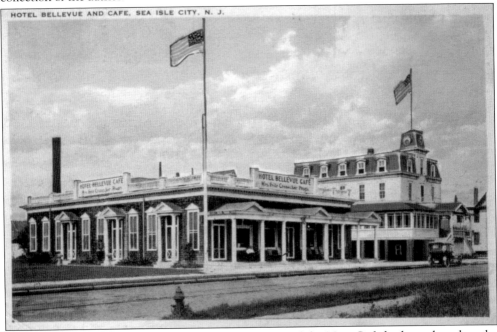

HOTEL BELLEVUE AND CAFE, SEA ISLE CITY, N. J.

By 1922, when this postcard was mailed, the shingles of the New Café had weathered to the deep, rich brown so often associated with older seaside structures. The color spoke to a sense of permanence and an embracing of the natural weathering process caused by the salt air. Notice that automobiles have replaced the horse-drawn carriages.

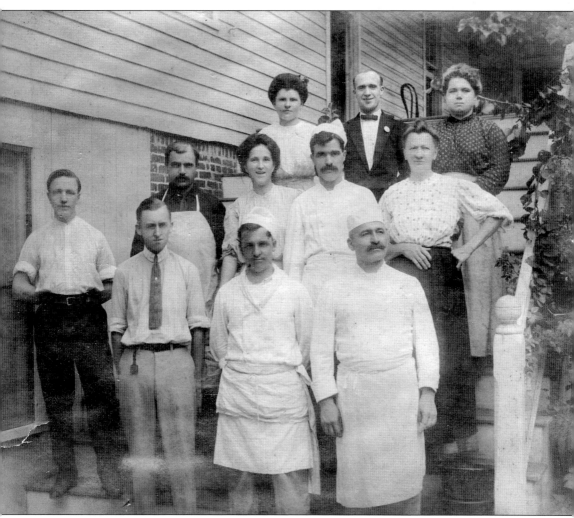

This wonderful old photograph shows the staff of Cronecker's posing on the back steps to the kitchen. The first two young men from the left in the front row are future Sea Isle mayors Richard W. and G. Fred Cronecker. Over the years, hundreds of young people have come to Sea Isle and worked as servers or kitchen staff at Cronecker's. A recent search of Facebook even turned up someone who had worked there in the early 1960s; he was looking to find out what had happened to the business, as he couldn't find it listed on the Internet.

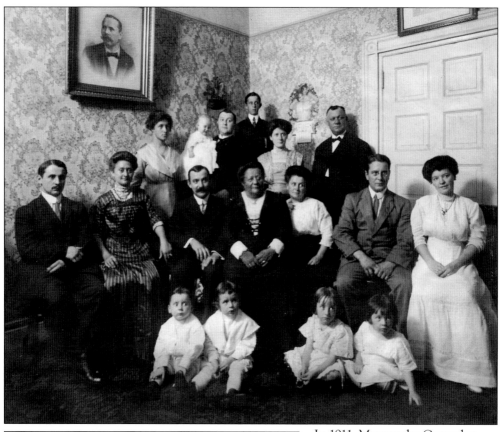

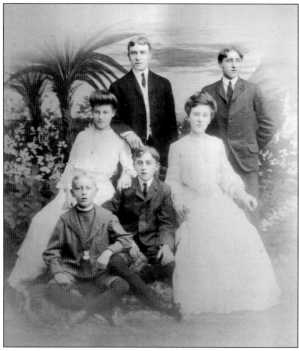

In 1911, Margaretha Cronecker celebrated her 60th birthday, surrounded by her very large family. With six children and now five grandchildren, there was no need for outside guests to make this a truly grand celebration worthy of a formal family portrait.

This undated portrait includes six of Fritz and Margaretha's eight children: Gustov Paul, George Frederick, Carl George, Charles George, Marie Mathilda, Wilhemina Carolina, Richard Wilhelm, and Maria Katharina. When Fritz died in 1895, Margaretha continued to operate the hotel until she died in 1927. Their son Gustov Paul inherited the establishment, and he, too, ran the business until he sold it to his niece Margaretta Pfeiffer in 1951.

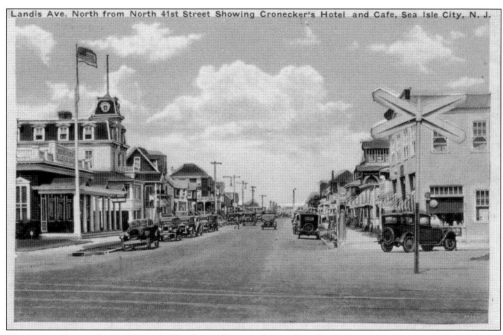

How times have changed! By 1939, the trolley tracks on Landis Avenue were gone, and a railroad crossing sign marked the intersection with the road from the mainland. Landis Avenue had been paved, and automobiles lined both sides of the street. Take particular note of the large American flag that continues to fly proudly in front of the New Café.

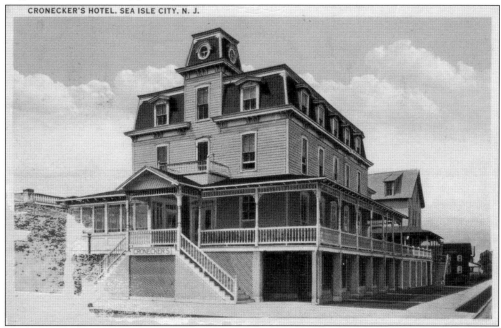

CRONECKER'S HOTEL, SEA ISLE CITY, N. J.

By 1947, the Bellevue had come to be known simply as Cronecker's. The New Café, having no heat, was closed shortly after each Labor Day, and the dining room was relocated to the main hotel building. The elegant meals were served in what can only be described as an atmosphere redolent of a living room, with guests made to feel like they were truly part of the Cronecker family.

Margaretta Pfeiffer, granddaughter of Fritz and Margaretha Cronecker, purchased the hotel from her uncle Gustov Cronecker in 1951. She had been working in the family business since 1927, with the exception of the World War II years, when she managed Pfeiffer's Department Store while her brother John G. Pfeiffer was serving as a lieutenant in the US Army.

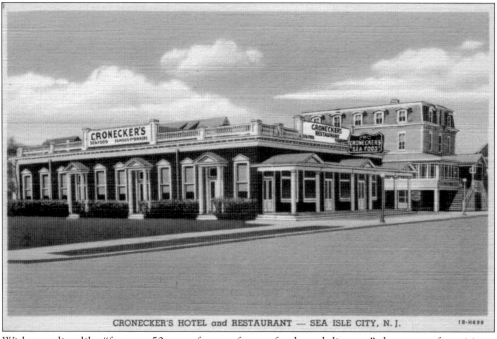

CRONECKER'S HOTEL and RESTAURANT — SEA ISLE CITY, N. J.

With a tagline like "for over 50 years famous for sea foods and dinners," there were few visitors to Sea Isle in the 1940s and 1950s who did not, at least once during their visit, enjoy a meal at Cronecker's. The signature lobster logo now appeared on all advertising, including the menu and napkins.

One of the most popular gathering places in town was the Rathskeller Bar, on the lower level of Cronecker's main hotel. Here, Eleanor Pfeiffer, sister-in-law of owner Margaretta Pfeiffer, gets ready to man the bar for the season's opening. Even the corsage she is wearing speaks to the excitement of the annual reopening of the Rathskeller.

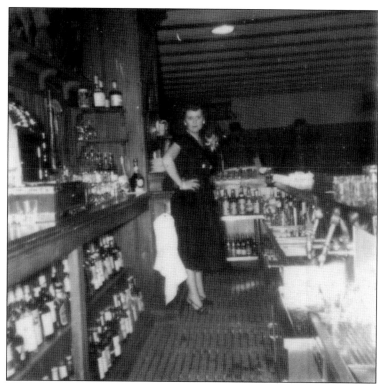

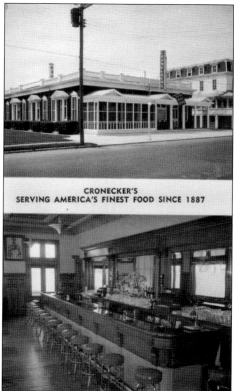

CRONECKER'S
SERVING AMERICA'S FINEST FOOD SINCE 1887

One of the last postcard views to be printed prior to the demolition of Cronecker's advertised the following: "A dining treasure in good foods. Always the ultimate in service. Nationally known for over half a century as one of America's best dining spots." Although a portion of the summer dining room still exists, incorporated into the LaCosta Lounge, long gone are the days of elegant seashore dining in the true Victorian style.

Known to most as the Summer Dining Room, this view of the south side of the building shows the large screened windows and doors that let the cool summer salt air into the dining room and main bar. Beautifully groomed flower beds always adorned each doorway, filled with hydrangeas, perennials, and roses.

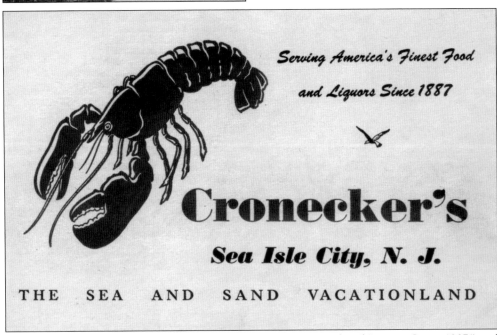

Serving America's Finest Food and Liquors Since 1887

Cronecker's

Sea Isle City, N. J.

THE SEA AND SAND VACATIONLAND

The cover of the menu boasted, "Serving America's Finest Food and Liquors Since 1887," and there were few who would dispute this claim. A dinner in the main Summer Room was always a special event. Each Sunday, a brunch combined great food with the best in seashore fashion, from Pfeiffer's Department Store just down the street.

Cocktails

Lobster 1.50

Jumbo Shrimp .85	Tomato Juice .15
Cherry Stone Clam .50	Crab Meat 1.00
Clam Chowder, Cup .25 Bowl .50	Snapper Soup, Cup .30 Bowl .60
Fruit Cup .25	Onion Soup, Cup .25

A La Carte

Steamed Clams 1.50 (Setup for 2 1.85)
Deviled Crab .95 Fried Shrimp 1.50
2 Soft Shell Crabs 1.50 Fried Scallops 1.25

Platters

Large Broiled Live Lobster	
Lobster Salad (No Vegetables Included)	2.50
Lobster A La Newburg	2.75
Combination Seafood Platter	2.35
Cold Seafood Platter	2.25
Fried Jumbo Shrimp, Tartar Sauce	2.00
Deviled Crab	1.85
Frogs Legs Saute, Garlic Butter	3.00
Soft Shell Crab, Cole Slaw, French Fried Potatoes	1.50
2 Soft Shell Crabs, Tartar Sauce	2.25
Crab Meat Au Gratin	1.85
Fried Filet of Flounder, Tartar Sauce	1.85
Broiled Filet of Flounder, Butter Sauce	2.00
Fried Scallops with Tartar Sauce	1.85
Half Broiled Spring Chicken	1.85
Chopped Tenderloin Steak, Onion Sauce	1.75
Breaded Veal Cutlet, Tomato Sauce	1.85
2 Broiled Lamb Chops	2.75
Chicken A La King	1.85
Broiled Sirloin or Tenderloin Steak	T 4.00 S 4.50

*Platters Include Two Vegetables, Cole Slaw or Chef's Salad
Roll and Butter*

Salads

Chicken 1.75	Lobster 2.50	Crab 2.00
Lettuce and Tomato .50		Shrimp 1.75

Tomato Stuffed with Crab Meat or Chicken Salad 1.50
Tomato Stuffed with Lobster Salad 2.00

Desserts

Ice Cream and Sherbets .25	Melon in Season .35
Fruit Gelatin with Whipped Cream .25	
Neapolitan Parfait .40	Floating Island Pudding .25

Beverages

Coffee .15. Tea .15 Milk .15
Iced Tea or Coffee .15

This menu folded and was printed as a postcard so guests could mail home a sampling of their vacation dining. The menu predominantly consisted of seafood, with lobster, shrimp, and crab taking center stage. However, sautéed frog legs, at $3, were the most expensive item other than broiled lobster, which, much as today, was offered at market price.

On The Way To Cape May

*A Love Story that begins in Ocean City,
and wends its way along the Jersey Shore through Sea Isle City,
Avalon, Stone Harbor, Cape May Court House, Wildwood,
and romantic Cape May.*

Words & Music by Bud Nugent

Recorded by Daddy Bean & Sunshine, Lored Records, Box 211 Wildwood, NJ 08260

The song "On the Way to Cape May" has close ties to Cronecker's Hotel. One summer in the mid-1950s, Maurice "Bud" Nugent and his family rented a house in Townsends Inlet. One rainy weekend, he drove his nieces and nephews to Cape May for the day. The trip was not easy, as roads were clogged with traffic. Responding to frequent calls of "Are we there yet?" Nugent started a sing-along, improvising words and music about the towns they passed through, including Avalon, Stone Harbor, Court House, Wildwood, and finally, Cape May. Nugent's pianist friend, Joe Gindhart, was performing at Cronecker's, and when he heard the "little ditty," he put the words and tune on paper and began playing it at the hotel. The song quickly became a local favorite, and when entertainer Cozy Morley heard the tune, he, too, included it in his nightly act. With Morley pushing it in every performance, the song's popularity spread throughout the Philadelphia region. Finally copyrighted in 1960, it continues to be an anthem for the Jersey Shore. Many local brides have danced to this beloved song, and the author's husband even has the title engraved in his wedding band.

Ten

THE MARCH 1962 STORM

For three days, beginning on March 6, 1962, two storms joined, and then stalled, over a stretch of about 600 miles, with Sea Isle City right in the center. Unlike a hurricane that blows in with extreme winds and rain and quickly moves on, this storm brought five high tides and total devastation to the island, and much of the New Jersey coastline. In the book *Great Storms of the Jersey Shore*, authors Larry Savadove and Margaret Thomas Buchholz note that, as the waves rose, "they mounted to a height of a three- or four-story building," but "records are incomplete because the storm destroyed the recording devises on the Steel Pier in Atlantic City." Sadly, most of the lovely old hotels, many of which had survived the Hurricane of 1944, did not make it through this three-day assault by Mother Nature. The three-story Windsor Hotel, the Fean Hotel, and the Madelyn Theater, along with the Excursion House and the Ocean Pier, all just simply washed away. As the storm intensified, many people had to be evacuated from Sea Isle by helicopter. Almost all of the city's 1,200 permanent residents evacuated, and almost every house in Sea Isle was flooded with four to five feet of water. Margaretta Pfeiffer was one of the few "civilians" who remained on the island for the duration of the storm. As the owner of Cronecker's Hotel and Restaurant, she refused to leave her lifelong home or to close the hotel. Instead, she provided room and board for the rescue and repair workers who helped save the town's residents at the height of the storm. At each high tide, Margaretta went down to the Rathskeller Bar and marked the spot on the wall to which the water had risen. At each day's low tide, she took her camera and documented the destruction going on all around her. Many of the pictures on the following pages were taken by Margaretta Pfeiffer and have never before been published.

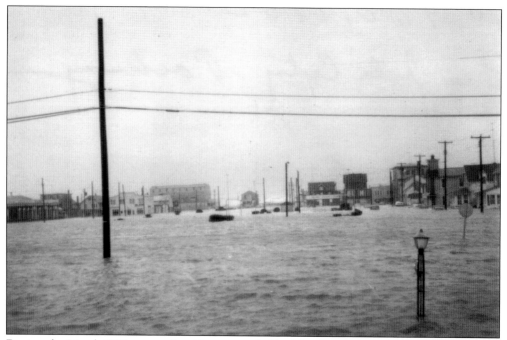

During the March 1962 storm, the tides rose and ebbed for three days. The bay and ocean met and did not part until the storm moved out to sea. Looking east down JFK Boulevard, water dominates the view. Cronecker's Hotel is visible on the far left, and cars are almost completely submerged on the right.

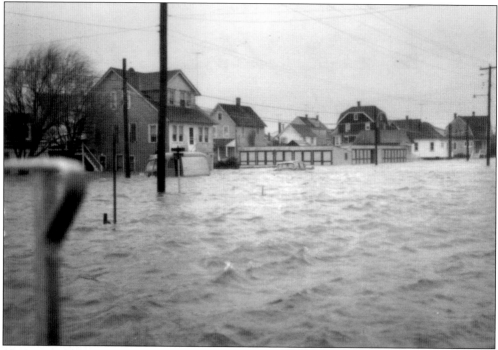

The corner of Forty-second Street and Central Avenue was completely submerged and remained so for three days. In some cases, cars floated from one side of the street to the other.

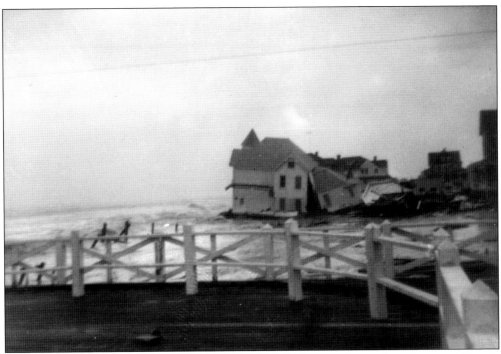

The power of the ocean waves was unstoppable. Even the largest of oceanfront homes and hotels were no match for the pounding surf.

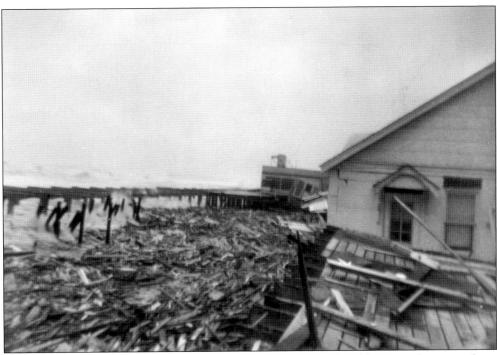

The boardwalk was completely destroyed and was eventually replaced by a paved promenade, as township officials acknowledged that a wooden structure was no match for Mother Nature's fury.

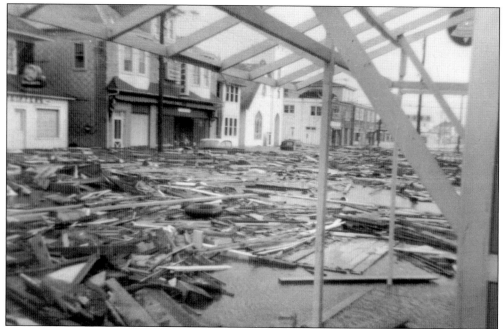

Locals knew that Pfeiffer's Department Store was on relatively high ground, so one clever resident parked his or her car up on the sidewalk in front of the store. The car was a total loss by the time the storm ended, yet its placement prevented the floating debris from breaking through the large plateglass windows of the storefront.

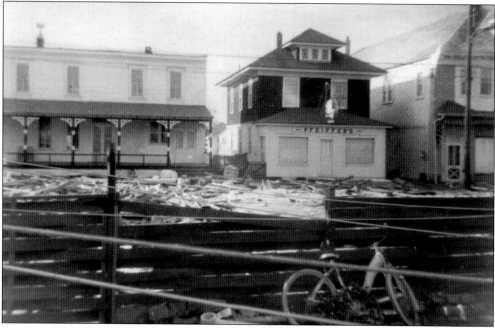

Once the floodwater had receded, Landis Avenue was buried in debris. Although the original Pfeiffer's had about four feet of water in it, the main store had only an inch of thick mud that had seeped under the front door, thanks to the car parked in front that buffered the windows from breaking.

Pieces of the destroyed boardwalk and house windows were piled three feet deep in front of Pfeiffer's Department Store on Landis Avenue. Cleaning up the overwhelming disaster left behind by the storm seemed a daunting and impossible task.

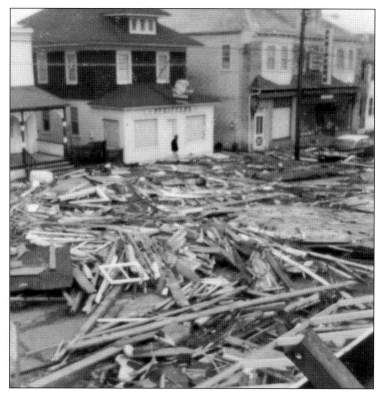

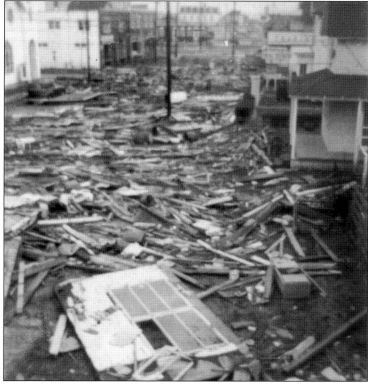

Looking North on Landis Avenue, the debris fills the street as far as the eye can see. The Lutheran church is visible at the top left.

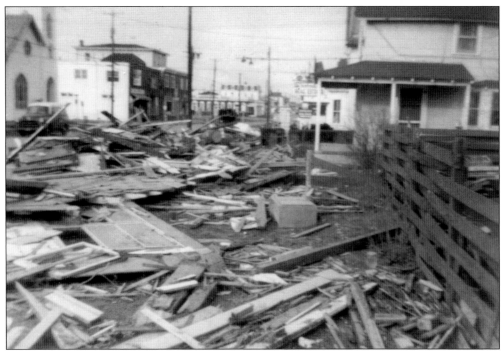

Taking a closer look from the ground level of Landis Avenue, the debris becomes more identifiable. Cronecker's Hotel can be seen in the distance.

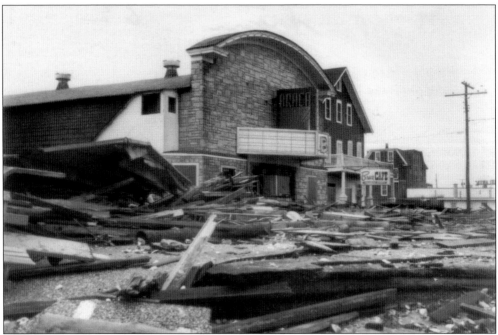

Opened in 1916, Braca's Movie Theater screened silent movies, run manually by John and Louis Braca, while Philomena "Minnie" played the piano for the 7:00 p.m. and 9:00 p.m. shows. Thursday was Bargain Night, featuring two movies, cartoons, and free dishes! By 1925, the movies were run by machine, and around 1935, the "talkies" came in.

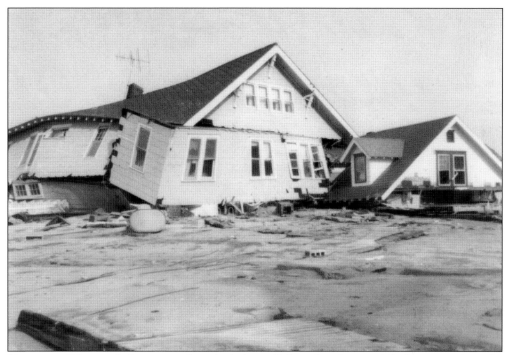

Houses on Fifty-ninth Street were knocked clear off their foundations. The home on the right appears to have completely lost its first floor. Putting these buildings back together would be like working on a jigsaw puzzle without the picture.

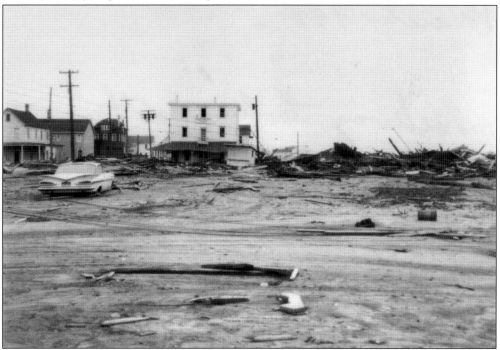

Looking north on the Parkway, the sand has settled everywhere. Buried in the sand is a dangerous mix of broken glass, nails, wood, and caustic chemicals.

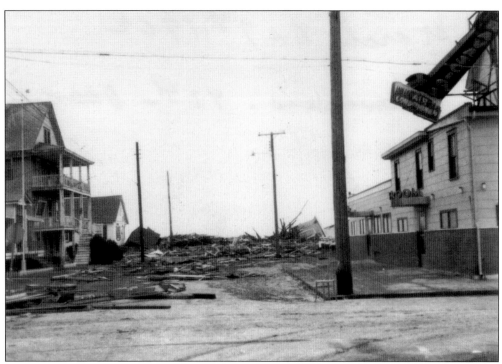

On March 6, the sign on top of Travascios Restaurant gave way to the pounding wind. This view is from Forty-third Street, looking toward the ocean.

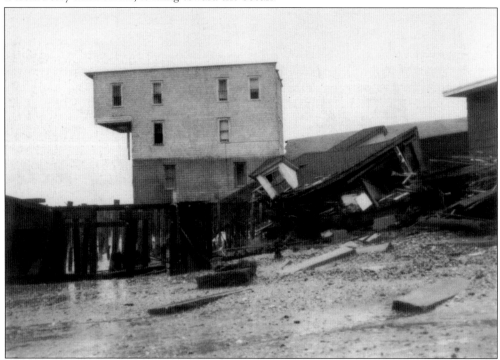

Taken on March 7, 1962, this photograph shows what little remains of the Donut Bar and the bowling alley.

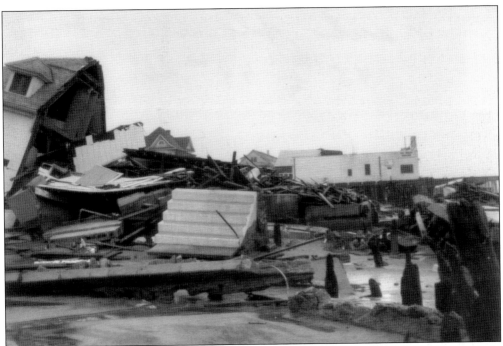

Looking along what used to be the boardwalk, between Forty-fourth and Forty-fifth Streets, only debris is visible. The buildings that had lined the boardwalk were all destroyed and, in many cases, unidentifiable.

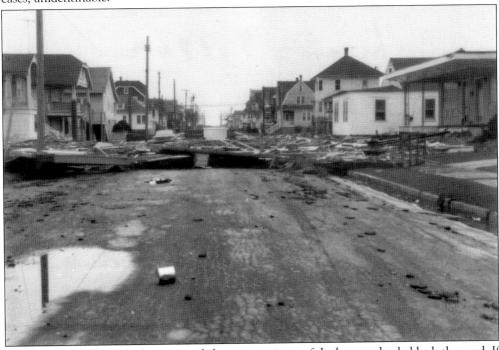

On Forty-third Street, looking toward the ocean, pieces of docks completely block the road. If the floodwater did not damage a home, the floating debris did, breaking through windows and knocking down porches.

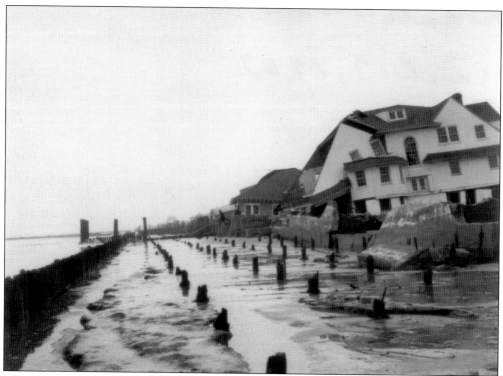

The Dante home directly faced the boardwalk before the 1962 storm hit. After the storm's conclusion, the home was "on" the boardwalk, tilted in precarious angles.

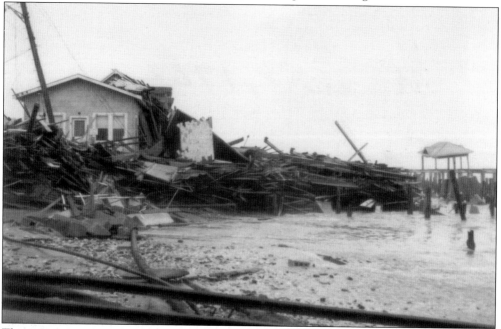

The massive Excursion House was nothing but rubble when this photograph was taken on March 7. Having survived the 1944 hurricane, the old building was no match for the three-day nor'easter and its pounding high tides.

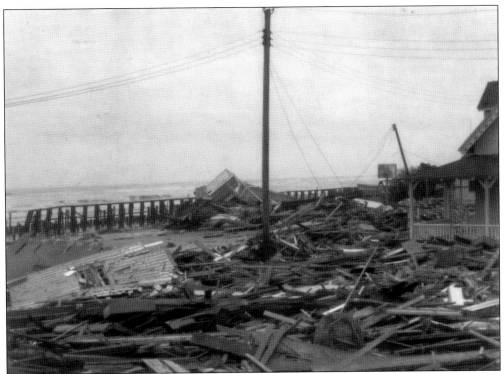

How the house on the right managed to keep its front porch is just an example of how unpredictable the storm damage was. At the corner of Fiftieth Street and the beach, the surrounding homes are nothing but rubble, but this porch still stands.

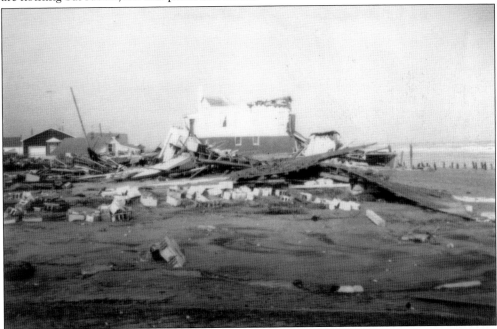

Scattered cinder blocks are the only things left of these beachfront homes. The force of the wind and water was too much for even the heaviest of construction material.

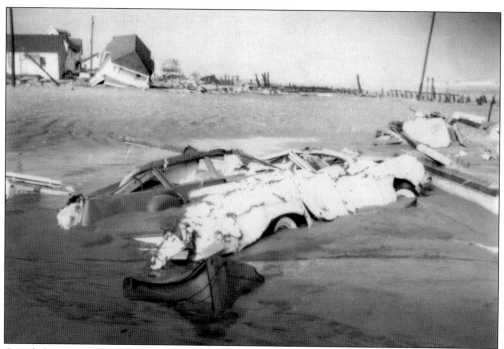

Cars left on the island during the storm never had a chance. Between the flooding salt water and the shifting sands, these two cars ended up on their sides, buried in the debris left behind when the tides had receded.

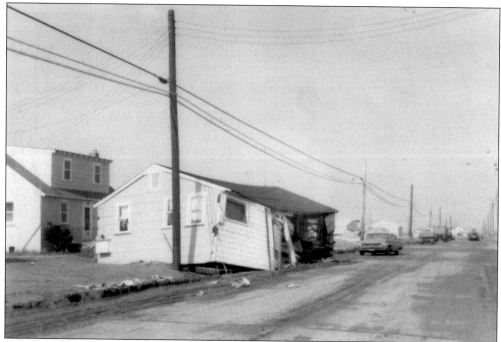

This house floated right off its foundation and was dropped halfway into the street at low tide. Many similar smaller homes ended up out in the marshes and partially submerged in the bay after the storm.

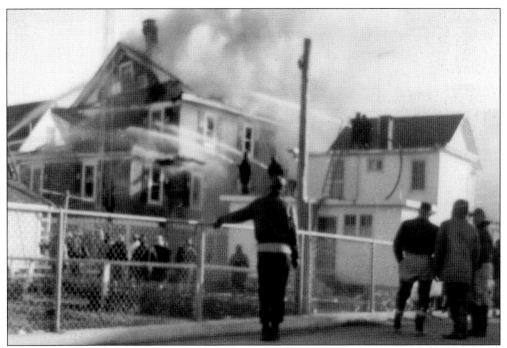

As if the storm had not done enough destruction, fires broke out caused by broken gas lines and downed electrical wires. It was hard to believe that, after being soaked in water for three days, anything would still burn.

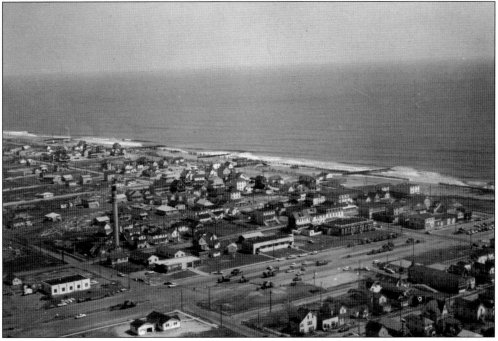

Eric Gustav Miller took this series of aerial photographs immediately following the storm. In this view of Forty-second through Thirty-sixth Streets, the boardwalk was gone and JFK Boulevard was lined with heavy construction equipment, ready to begin clearing sand and debris from the streets.

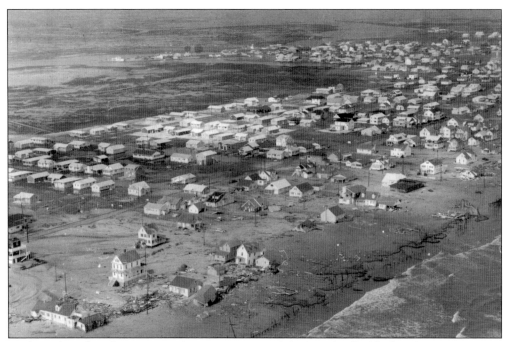

With nothing but the support pilings remaining of the boardwalk, blocks of town were now under sand, with little protection from the next incoming tide. Some blocks had lost almost every structure, and road access was completely gone.

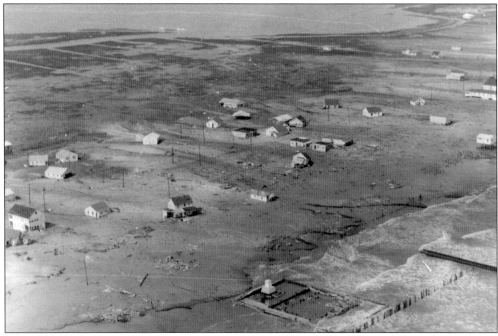

Strathmere appears like a ghost town. No roads and no undamaged buildings remained. Notice the house on the far right standing on its pilings, with all the sand completely washed away from around the foundation. You could walk under a house and look straight up to the roof, as the power of the storm surge had simply sucked all the floors right out of the house.

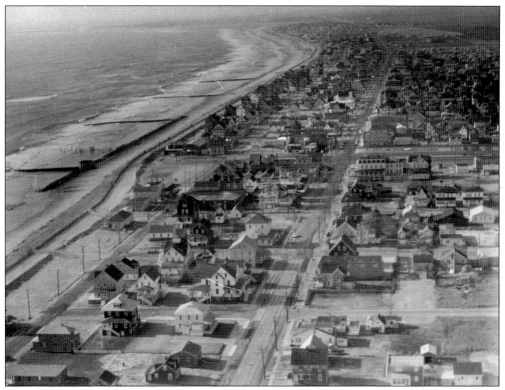

Eric Gustav Miller made a return visit to take aerial photographs of Sea Isle on February 2, 1963, just 11 months after the island's devastation. The boardwalk's support pilings can be seen well out into the water, and construction has begun on the new promenade. While some of the grand old hotels survived, like Cronecker's, which can be seen in both photographs, those that had lined the boardwalk are all gone, making Braca's Movie Theater a block closer to the beach.

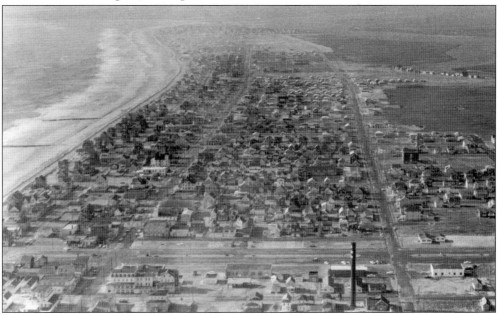

Discover Thousands of Local History Books
Featuring Millions of Vintage Images

Arcadia Publishing, the leading local history publisher in the United States, is committed to making history accessible and meaningful through publishing books that celebrate and preserve the heritage of America's people and places.

Find more books like this at
www.arcadiapublishing.com

Search for your hometown history, your old stomping grounds, and even your favorite sports team.

Consistent with our mission to preserve history on a local level, this book was printed in South Carolina on American-made paper and manufactured entirely in the United States. Products carrying the accredited Forest Stewardship Council (FSC) label are printed on 100 percent FSC-certified paper.

MADE IN THE
USA